Variations in Watercolor

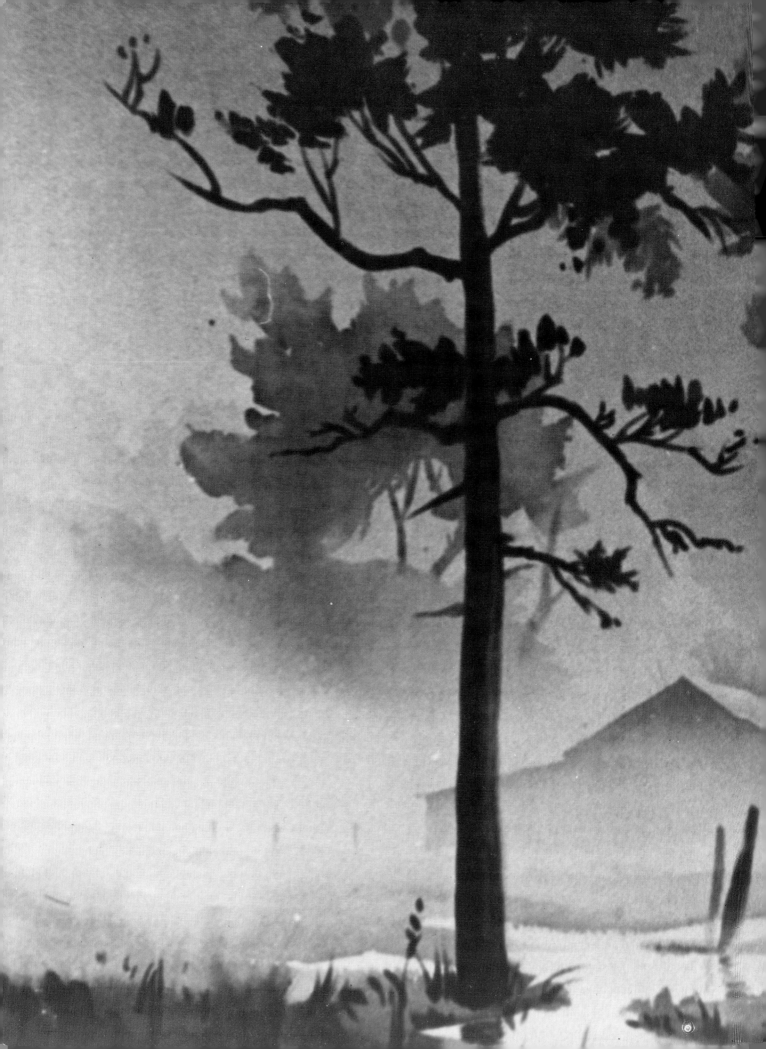

Variations in Watercolor

Naomi Brotherton
text by Lois Marshall

North Light Publishers

To Lem
To Betty and Bob
and to my Mom

I wish to express my appreciation and gratitude
to the distinguished watercolorists who
contributed special thoughts on watercolor
painting for this book. Through the years I have
admired their work and several have had
particular influence on my work as I sought
them out for instruction.

Published by NORTH LIGHT PUBLISHERS, an
imprint of WRITER'S DIGEST BOOKS, 9933
Alliance Road, Cincinnati, Ohio 45242.

Manufactured in U.S.A.
First Printing 1981
Second Printing 1983

Library of Congress Cataloging in Publication Data

Brotherton, Naomi.
 Variations in Watercolor.

 Bibliography: p.
 Includes index.
 1. Water-color painting--Technique. I. Marshall,
Lois, 1913- II. Title.
ND2420.B78 751.52′2 81-18704
ISBN 0-89134-043-2 AACR2
ISBN 0-89134-045-9 (pbk.)

Edited and Designed by Fritz Henning
Composition by Creative Group, Inc.

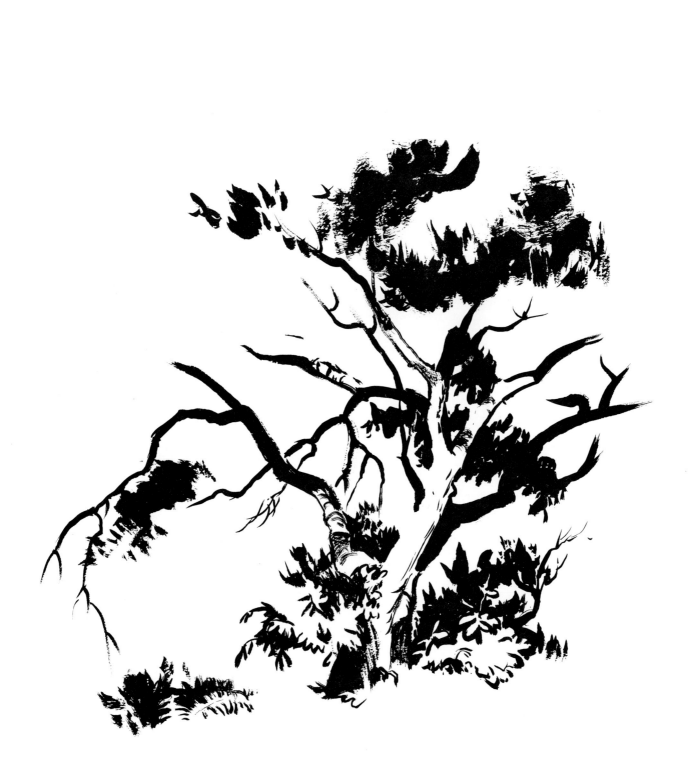

Introduction

Watercolor is called a transparent medium because the pigments can be diluted with water and brushed on paper in such a way that light shines through the color and is reflected back by the white paper. Artists like to call themselves purists if they use no white pigment. However, a careful examination of watercolor pigments reveals that there is a vast difference in the transparency of even the finest tube watercolor pigments. Some colors indeed are clear, staining, non-sedimentary, and very transparent on paper. Others are non-staining with considerable sediment that rests on top of the paper and more or less stops the light. They are less transparent and may be quite opaque if applied in a heavy consistency. Naomi Brotherton's palette is made up of those pigments which are staining, non-sedimentary, and truly transparent. Her test of a good watercolor painting is that the picture glows in the semi-darkness.

Variations is a musical term indicating repeated modifications in rhythm, tune, harmony or key. Variations in watercolor painting implies similar modulations, all of which require the painter to master a variety of techniques. Here the artist shares with you many ways of exploring the fascinating interactions between water, paper and transparent color.

Watercolor paintings serve best to help you *see* possible variations. Beginning students are challenged with completed pictures and basic concepts spelled out in easy to follow, concise detail. More complex pictures and techniques stimulate advanced artists. Each subject area explores good design principles, including a variety of methods for editing pictures.

Creating good design is the central emphasis. However, instead of presenting a lengthy discussion of a complicated concept, good design principles are explained step by step, one at a time, throughout the text. Each topic and each picture is a step toward some important principle of good design. A brief summary is given at the conclusion. The entire index is on design, and pinpoints the specific elements and principles of good design as they were introduced and discussed. The Table of Contents is specific and detailed so you can locate the subject of interest to you.

The final section should be helpful to all art students, but it will be of particular value to advanced artists who hope to enter juried shows. Here you will find a variety of prize winning pictures by outstanding painters. Each artist tells in his own words why he thinks his picture was selected by judges for award. Each one also explains what he looks for when he serves as a judge for a watercolor exhibition.

It is hoped the beginner and the experienced artist will find this approach to the wonderful variations of transparent watercolor direct, concise, specific and helpful.

Lois Marshall

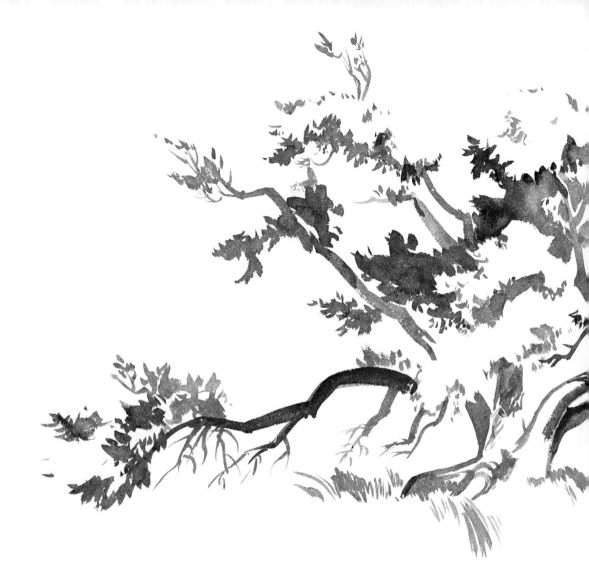

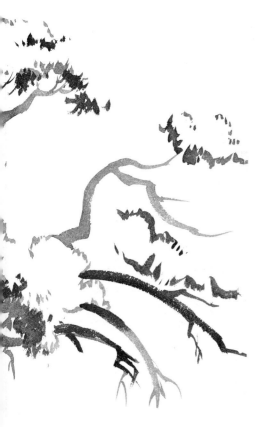

1 Variations on color

*I*n the beginning the earth was without form, and darkness moved over the deep. In the first act of creation, there was light. And when there was light, there was color—beautiful, brilliant, vibrant color.

Color always has been a part of life. However, it was not enough for us to revel in the blue of the sky and water, the green of the grass, and the rich reds and yellows of the flowers. We have a need to create our own colors.

Stone Age man mixed earth, pulverized bugs, precious stones, and berries with water and made different colors to paint shapes on rocks and cave walls and to decorate his body. In the dawn of civilization, the Etruscans and Egyptians decorated their tombs with a sort of water-color medium consisting of rich, grayed, earth tones and vibrant blues. As early as 500 A.D. the Chinese and Japanese painted with diluted inks on fine paper. These water-mixed solutions mark the beginnings of the fine art of watercolor painting.

Development and Organization of Color

Even though man loved and wore colors, and even though he brilliantly decorated his homes and baskets, for many years he had no way to organize his thinking about color. It was like speech. Man communicated with grunts and gestures, but he had no alphabet with which to structure his language and record his thinking. According to tradition, it was not until around 1375 B.C. that the Phoenicians developed the alphabet from sounds, gestures and pictures. The alphabet made possible man's development from savagery to civilization.

In a sense, the development of the color wheel can be likened to an alphabet for controlling color.

Around 1666 Isaac Newton studied a beam of light passing through a prism and emerging in a spectrum of color—red, orange, yellow, green, blue and violet. When the ends of the visible spectrum were brought together, the purple formed. This gave rise to the idea of charting light colors in a circle. When all the light colors were mixed together, the result was white light. The colors of light are the realm of the physicist, for as every first grader knows, you do not get white when you mix together all the pigment colors of paint. You get black. Significant efforts were made by Herbert Ives, Ostwald, Munsell and others to organize into a meaningful plan the pigments of the artist. It was not until 1831 that David Brewster defined the three hues that could not be mixed from any other colors. He called them the primary colors — red, yellow, and blue.

Strange is the simplicity of truth. All music is written from only seven notes. All the millions of numbers can be made by combining nine digits and zeros. All the words in the languages of a vast portion of the globe are made from only twenty-six letters. So all the variations of colors in all the pictures of the world are mixed from three primary colors — red yellow and blue.

Like the alphabet, the multiplication tables, and the musical scales, the primary colors are taught in elementary school. And watercolors are among the first paint mediums given children. So in school, children learn early that the three primary colors are placed equidistant in a circle called the color wheel. The secondary colors are placed equidistant between the colors used to mix them, and variations of these colors are appropriately placed between them. Youngsters also learn that the colors directly opposite each other on the color wheel are called complements.

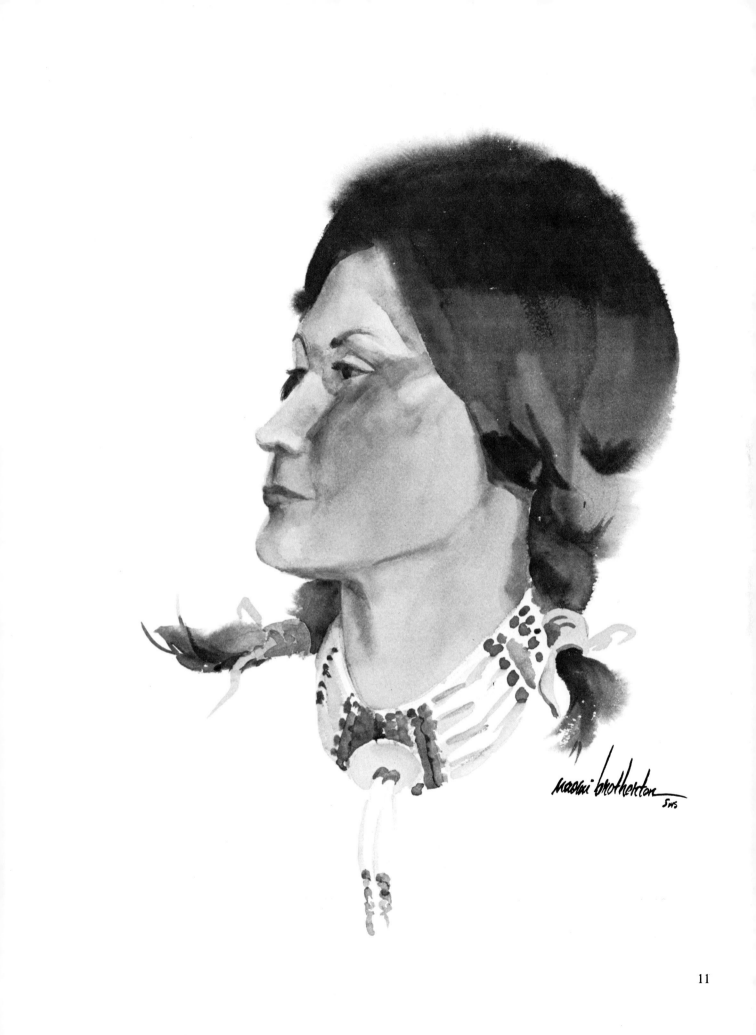

Study In Grays
Private Collection

Award winning picture in the Southwestern Watercolor
Society Annual Juried Show

Family Portrait is a study in grays. Indigo and
brown madder mixed in equal parts make a neutral
gray. With more brown madder than indigo, it be-
comes a warm gray. With increased water, it can
appear very light, but because indigo and brown
madder are both deep colors, they can produce a dark
gray. If the color leans toward a purple, a little New
Gamboge will neutralize it. In this painting, warm
grays are contrasted side by side with cool grays, the
lighter tones against the darker.

The palette was indigo, brown madder, New Gam-
boge, and Winsor red. I painted washes of transpar-
ent color in correct values on dry stretched paper.
Subtle color and contrast can create a satisfying ex-
perience in a painting.

Family Portrait

Transparent Watercolor

Transparent means something you can see through, or, as if lighted from
within. In transparent watercolor light shines through the paint as the
white of the paper underneath reflects the light. Watercolor pigment from
the tube can be diluted with water and applied to paper in such a way that it
is transparent. Transparent watercolor usually relies totally for its light
qualities on utilization of the paper as part of the medium. Watercolor
mixed with white pigment becomes an opaque medium. Also, it can be ap-
plied as a thick mixture that is opaque. That is to say, the pigment stops the
light and does not let is pass through the color to be relected by the white
paper. It is easy to distinguish between the effects of transparent water-
color and those of opaque watercolor. The transparent wash seems to glow
with light.

Transparent Pigments

Watercolorists who do not use white paint in any form, and paint only
with the transparent pigments, sometimes like to call themselves
purists. However, a careful investigation of the finest watercolor tube

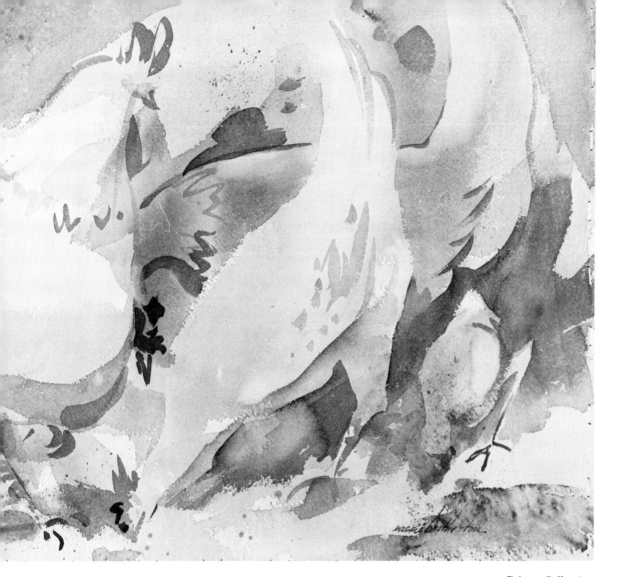

pigments will reveal that different colors vary greatly in transparency. There are pure, brilliant, non-sedimentary, usually staining colors that clearly let the light pass through and reflect the paper. There are also tube watercolor pigments with considerable sediment which, when applied to paper, rest on top of the surface and more or less stop the light. That is, they are more opaque pigments.

To me, one of the charms of watercolor painting is the excitement of transparency. It is a delight to see the glow of white paper reflecting through color. This devotion to transparency led me many years ago to select from the available watercolor pigments those which tend to be the most transparent, and they compose my palette.

It is not essential for everyone to be happy working only with the transparent pigments, nor do I have any argument with those who like to use opaque watercolors, acrylics and other less transparent mediums. The paintings in this book are completed entirely with my chosen palette of transparent pigments. I urge you to try these and other transparent pigments. They have the special advantage of making it difficult to create muddy looking colors. This is no small asset, particularly for a beginner.

My Palette

My palette consists of the following transparent pigments:

Warm Colors	Cool Colors
Winsor red	Winsor green
Brown madder	Winsor blue
Alizarin crimson	Indigo (very dark grayed blue)
New Gamboge (yellow)	Sepia
	Winsor violet
	Antwerp blue

In addition, I sometimes use raw sienna, burnt sienna, French ultramarine blue, which seem to be somewhat less transparent than the above pigments. I use them sparingly and well diluted with water so they will glow. Occasionally I use burnt umber for spatter or dark interiors, even though it is not really a transparent pigment.

Test for Transparency

My chosen palette does not exhaust the list of available transparent pigments. The test for transparency is to dissolve a dab of pigment color about the size of a pea in about two ounces of water. Put the solution aside overnight. If the color is still in solution the next morning, you can be sure the color will glow with transparency when painted on your watercolor paper. If there is sediment in the bottom of the glass the pigment has opaque qualities, and if almost all the color settles on the bottom, leaving only a faintly tinted solution, the pigment will tend to shut off the glow of reflected light. Try testing pigments you especially like this way and you may discover additional transparent colors you would like to use.

Properties of Color

For ages it was thought musical tones had to be retained in memory because there was no way to record them. With the development of musical notation it was possible to record scales, key, pitch, tone and intensity. Once this simple musical alphabet was understood, symphonies and other complex forms of music became possible to record and pass on to succeeding generations. In a similar way art students struggled for years for the want of color terminology and language. With the organization of color into a meaningful color wheel, it was determined that every single color had three basic properties — hue, value and intensity.

Hue is the identifying name of the color, like red, blue, green, blue-green, or orange.

Value is the darkness or lightness of a color. In watercolor it is how much water is used to dilute a pigment.

Intensity is the degree of brilliance or dullness of a color. Highest intensity of a given pigment is the color right from the tube. However, many purchased tube pigments are actually colors that are grayed mixtures. For instance, brown madder as it comes from the tube is a grayed red and has a low intensity.

We live in the richest age ever from a color point of view. Lavish color surrounds us wherever we are. It even extends into the night with flashing artifical lights in a myriad of hues. For the watercolorist, the same is true of the pigment we can buy. It is almost impossible to enumerate just the reds that are available from different markets, carrying exotic names such as scarlet lake, geranium and permanent rose. The artist scarcely knows when to stop buying the new delightful pigments, and the beginning artist is at a loss to know which ones are most needed.

Color Schemes

What is a good color scheme for a picture? Colors carry an emotional quality, and everyone has his own likes and dislikes. Pick one you like. The choice of colors should be appropriate to the subject you are painting. For example, dark values and grayed hues might not be appropriate for a flower garden scene.Usually, a good color scheme makes use of one dominant color for unity, but it also involves contrast and variety.

Webster defines a *scheme* as a plan of action. Scales and theory have not been found to be incompatible with musical creativity, so a study of color relationships need not inhibit free artistic expression.

Since Newton's day much has been learned about color by physicists, psychologists and artists. Intervals of color that produce harmony have been worked out through years of study and experimentation. The best known ones are included in the following presentation of eight color schemes. They do not exhaust the possibilities, but these are generally accepted and widely used.

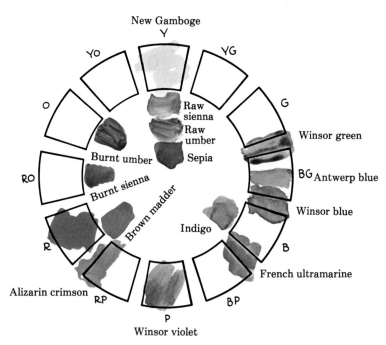

Color Wheel of Pigment Colors

To help you understand the effects of transparent colors, I have painted pure pigments in the approximate position they would occupy on the color wheel. New Gamboge is the yellow at the top. The hues between Winsor green and Winsor red have to be mixed. Some pigment colors are painted between the color slots because by themselves they are not truly typical of the actual color on the wheel. The grayed shades are toward the center, including raw sienna, burnt sienna, and brown madder. The indigo is toward the center between the ultramarine and Winsor blue.

Color Wheel of Mixed Transparent Pigments

This diagram shows all the colors of the color wheel achieved by mixing only transparent pigments from my palette.

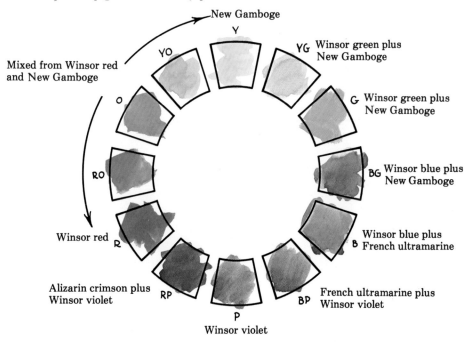

Color schemes and limited palettes are not a means of cutting off from any artist the use of countless colors and shades existing in the real world or the private domain of his imagination. Rather, the color scheme is a means of expanding your horizons in the use of color. It is like dipping into the ocean. You can use a spoon and carry away a spoonful of water, or you use a bucket and carry away a bucket full of water. In painting, knowledge, understanding and experimentation enlarge the capacity. The use of transparent color, limited palettes and color schemes planned with imagination will help to broaden your viewpoint and sharpen your creative capacity. These are suggestions and possibilities, not strict rules. It is an attempt to acquaint the artist with new dimensions of color harmony which will give you freedom to plan your own colors with new insight.

Eight Color Schemes

Monochromatic color scheme is the use of *one* color in all its tints and shades. It can be mixed with its complement to gray it.

Analogous color is the use of adjoining colors, neighbors on the color wheel. Use no more than one third of the color wheel at a time. This means you will use four colors, but any four neighbors will have a primary in common. This common color creates a pleasing relationship between the colors. For instance, yellow can go toward blue and you have yellow-green, blue-green, green, all of which have the yellow in common. Any and all of these colors can be used in different values and intensities. One color should be dominant, and it is better not to use equal intensities or equal areas for any two colors.

The *complementary* color scheme is the extreme in contrast since it consists of the two colors opposite one another on the color wheel. Mixed together the two colors neutralize one another and make a gray. A color can present a wide range of grayed tones by using different amounts of each complement. One color should be dominant in area, intensity and value. *Dried Leaves* (pg.26) is a complementary scheme.

Two other color schemes are related to the complementary color scheme, the split complement and the double complement. The *split complement* leaves out the opposite color on the wheel, but uses the two colors on either side of the complement. This color scheme becomes more exciting with the use of three colors and is usually a more interesting combination. The *double complement* employs any two adjoining colors and their opposites or complements. Four colors are used, and because the contrast becomes great, the use of a dominant color and grayed tones becomes important.

The *triad* color scheme is without doubt the one of greatest contrasts because it can include the three primary colors — red, yellow, and blue. If these colors are used, one hue should exist in a minute amount, one color should be dominant, and probably two of them should be grayed. If you use the other three triad colors, two of the colors will contain a common hue. Only four triad color schemes are possible, because with the fifth movement on the color wheel you begin to repeat triads.

The noted watercolorist, Rex Brandt, uses two other color schemes I like very much, the *semi-triad* and the *complement plus one-half*. Both of these schemes have two colors that contain a common hue, yet they admit of three exciting colors. These color arrangements offer unlimited experimentation in color harmonies, especially if only transparent pigments are used.

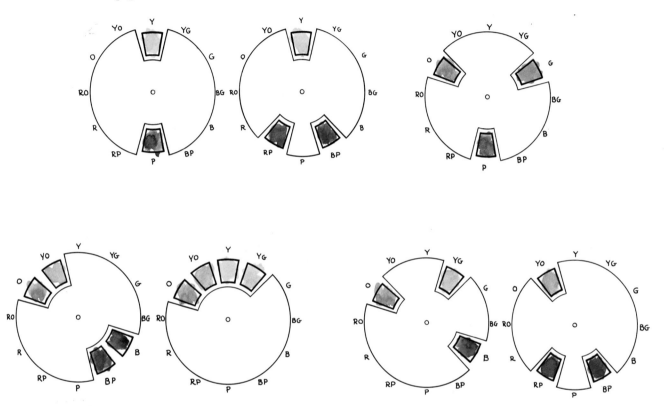

Disks for Color Schemes

Using your chosen pigments, make your own large color wheel on a piece of good poster board or on some other lasting, heavy paper. Keep the intensity of your colors strong. Then, using the measurements of *your* color wheel cut seven disks. On one cut out the opposite slots for the complementary color scheme. This disk can be turned to every position to see all the different complementary colors. Cut each one of the disks to represent a different color scheme, as demonstrated on the above chart. The different disks can be used on the same color wheel.

Using these color schemes will open a new awareness into color combinations you have never before experienced. Any pigment you wish can be used to mix the different combinations, so long as you keep the hues of the color scheme. You can gray these colors with the complement and you can use any number of the shades and tints of the chosen colors. Your imagination is your only limitation. Take care in selecting the dominant color for it will change the mood of the entire painting.

**Complement —
Red and green**
 Complements mixed together gray each other. When used side by side, they make each other appear more brilliant.

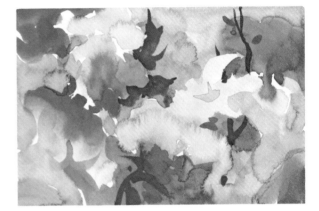

**Split Complement —
Orange, blue, purple, and blue-green**
 Blue is common to both the purple and the green. There is a cool dominance

**Double Complement —
Yellow, yellow-green, purple, and red-purple**
 Four colors offer great variety in hues and intensities.

**Analogous —
Yellow-green, yellow, yellow-orange, and orange**
 These colors are neighbors on the color wheel and have a close harmony with the yellow.

Using Color Schemes

Here are a few examples showing the use of different color schemes. Examine them and try making some of your own.

 Note the dominant color and how it influences the mood of the picture. The colors vary in the amount of space they occupy. There is variety. Some colors are grayed. Some are used in strong intensity while others are tints. Notice how the contrasts and complements enhance each other.

 These color schemes have been developed by outstanding artists over the years, and the color intervals on the wheel have been proven effective.

Triad—
Red, yellow, blue
 The yellow and blue are grayed. The warm tones are dominant.

Complement Plus One Half—
Red-orange, blue-green, yellow
 This particular color scheme is easy to use because the yellow is contained in all the colors.

Semi-triad—
Yellow-orange, blue-purple and yellow-green
 As you turn the disks on the color wheel, you will find exciting combinations.

Semi-triad—
Yellow-orange, yellow-green, blue-violet
 As you gray colors, change dominant hues, and make other variations, you will discover limitless possibilities.

Limited Palette Versus Color Scheme

There is a difference between using one of the color schemes and a limited palette. With a limited palette the artist chooses a few pigments. He can use any color he can mix with his selected pigments. They will be harmonious because the same pigments used in different color mixtures tend to produce a pleasing relationship. Using a selected color scheme, on the other hand, means that you can use any number of pigments you desire, but they must be limited to the colors in the color scheme selected. You also can use the chosen colors in any value from dark to light, and from pure intensity to all the grayed tones. Color gradation from grayed to pure intensity of the same color may be exciting, and should bring harmony. The proper control of dominant color helps establish unity.

Arbitrary Use of Color

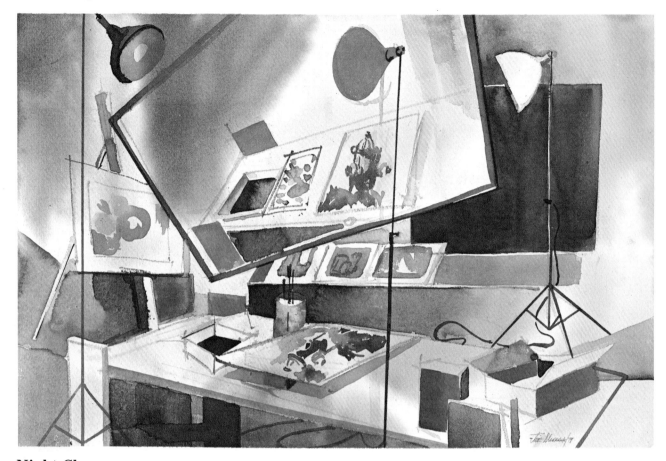

Night Class by Joe Marra
14 x 22 inches

Here is a student's painting made after a class on color
schemes. The mirror reflects my demonstration table on
which my class demonstration painting is suggested.
Included are the floodlights and easel with a picture on it.
The color scheme used is a complement plus one-half: yellow,
purple and red-orange. It is a fine example of the arbitrary
use of a color— *arbitrary* meaning selected at will without
reason.

Subdued Triad

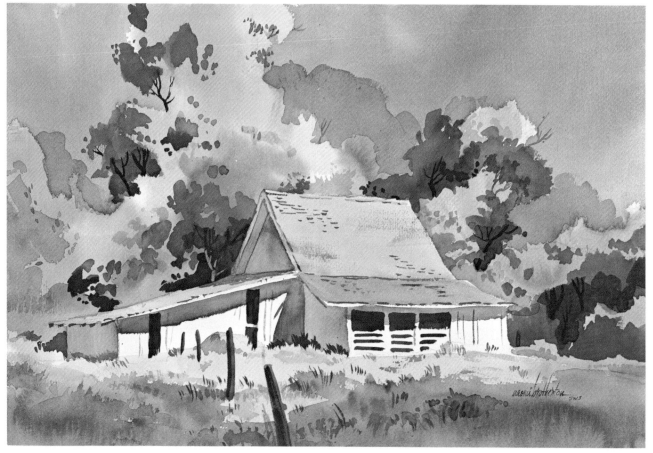

Harvest Gold

To me, the charm and thrill of watercolor painting is the excitement of transparency. I love the glow of white paper reflecting through color...I like the challenge of using transparent pigments.

Making Bright Colors More Brilliant

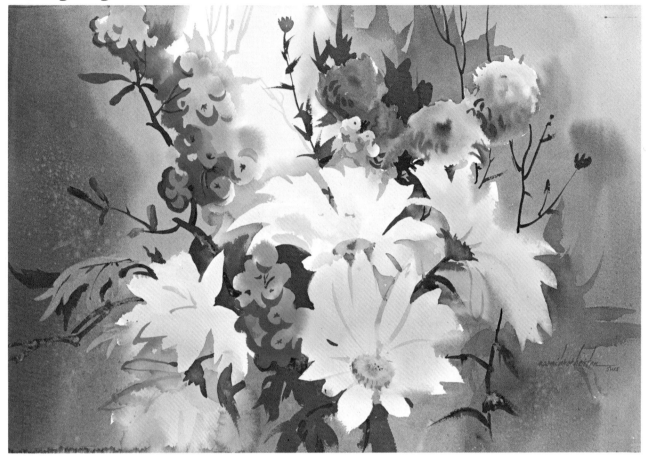

Fall Flora Collection of Ruby Huesing, Irving, Texas

Exciting color commands attention in a painting. It will attract a viewer from across the room. But beautiful color combinations are more than just painting with brilliant pigments.

Of great significance is the understanding of how one color influences another. The purple complement in this painting enhances the brilliance of the yellow daisies. The dark green leaves contrast their complement, the red. The gray background, by contrast, gives brightness and luminosity to the flowers. The white is contrasted by darks. The neutral green leaf at the left was lifted from the background with a stencil and a damp sponge. After the area was dry, the darker leaf was added to make a more interesting shape. The shadow in the top light was added so the white would not appear too stark. It also creates another dimension.

The palette was New Gamboge, Winsor red, alizarin crimson, brown madder, indigo and Winsor violet. To achieve in your painting the feeling of brightness you see in the flowers, it is best to use pigments as near the actual flower colors as possible.

Here the color scheme is a semi-triad yellow, purple, and red. Note the value changes throughout the painting, with contrast in intensity.

Warm and Cool Colors Analogous Color Scheme

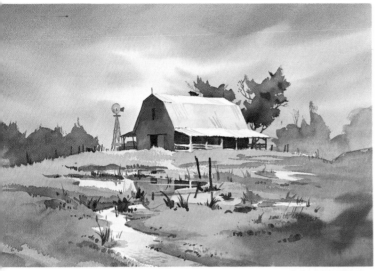

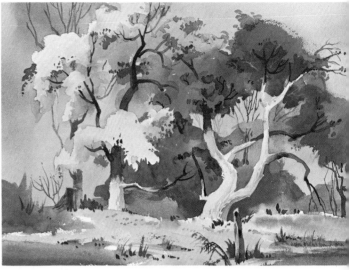

Spring Rain Autumn Splendor

Collection of Mr. and Mrs. W.D. Lasater, Pecos, Texas

Spring Rain is a warm painting with the vertical light moving from the sky, over the roof, and down through the water to oppose the horizontal emphasis of the ground plane.

Whether a color is warm or cool depends on surrounding hues. The yellow-green is within itself a warm color. Looking at it in contrast to the gray sky, it appears warm. However, the warm red foreground makes the yellow-green seem cool, and it remains in the distance.

Landscapes do not have to be painted with blue skies, blue water, and green grass. This landscape is a semi-triad color scheme—red, orange, and green. The grays are neutrals. Besides indicating a passing spring, they act as a foil against which the colors are intensified.

The puddle repeats the sky gray in the foreground. It lies flat as water should because of the horizontal lines at the back and the land projections drawn in perspective.

The color scheme in *Autumn Splendor* is analogous. Beginning with yellow-green, it includes yellow, yellow-orange, and red-orange. The grayed sky enhances the brilliant colors. Many different values of the colors are used.

The palette was Winsor red, New Gamboge, Winsor blue, indigo, and brown madder.

The method consisted of painting direct washes in the correct values and colors on stretched 140 lb. Arches paper. The tree shapes were painted first and then the sky. The darks were painted after the mid-tones had dried. Yellow is a difficult color to gray; to be bright, it must go either to the green side or to the orange side. The darks were allowed to flow together, helping to create the "watercolor" look.

25

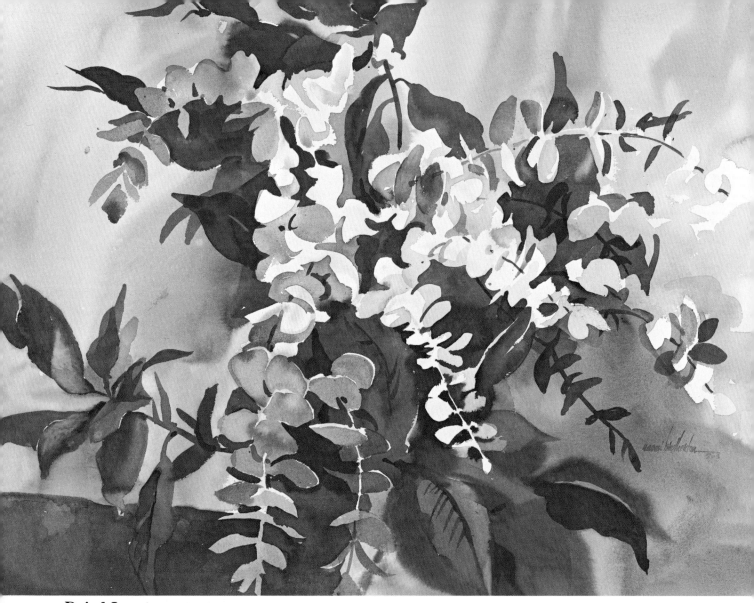

Dried Leaves Private Collection

Zoltan Szabo Award
1979 Annual Juried Show
Southwestern Watercolor Society

Drama in Orange and Blue

The palette was New Gamboge, brown madder, indigo, French ultramarine blue, Winsor red and Antwerp blue.

The color scheme is the complement—orange and blue. Three blue pigments made possible many variations of blue. The orange colors range from the lightest tints to the darkest shades. The color schemes may limit the number of colors used, but there is no limit to the pigments from which the colors can be mixed, nor to the variations in which they can be painted. Keeping in mind the complementary color scheme and the palette used, look at the variations of oranges and blues in the painting.

With the plants actually in view, I began shaping the eucalyptus leaves by painting in the dark magnolia leaf shapes behind them. Some darker darks were dropped in while the paint was still wet. No pencil drawing was done first, so I exercised freedom to achieve the grace of the leaves and branches. Actually, I began in the center and worked outward.

The oblique areas and a curvilinear dominance keep the picture from being static. The horizontal at the left provides conflict and interest and gives a calming effect to the obliques. The lights dramatically positioned against the darks serve as eye-catching elements.

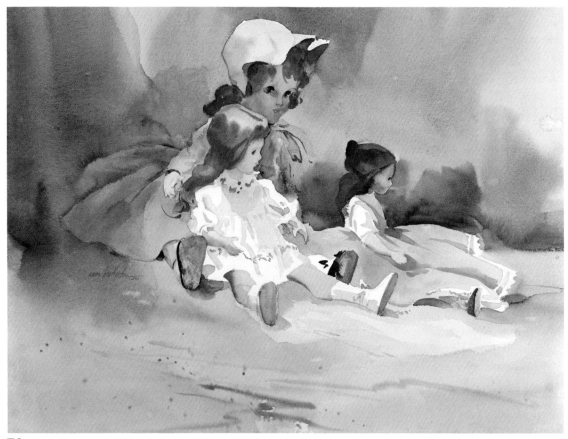

Playmates *Collection of Mr. and Mrs. Michael Crudden, Dallas, Texas*

Simplicity in Orange and Blue

The complementary color scheme of orange and blue become a dramatic presentation of deep contrast with variety in *Dried Leaves*, which is a dominantly warm picture. In *Playmates* the same color scheme of orange and blue becomes a basically cool painting with subtle contrast and simplicity.

A certain mystery is created in areas where the values are close and there is only a color change. The variety in the hues and values of the blues stimulates the interest. The contrast of the skin tone and hair creates excitement against the complementary blues. The whites lead the eye in and bring the eye back to the center of interest.

Dried Leaves and *Playmates* demonstrate how different two pictures can appear, even though they have the same color scheme.

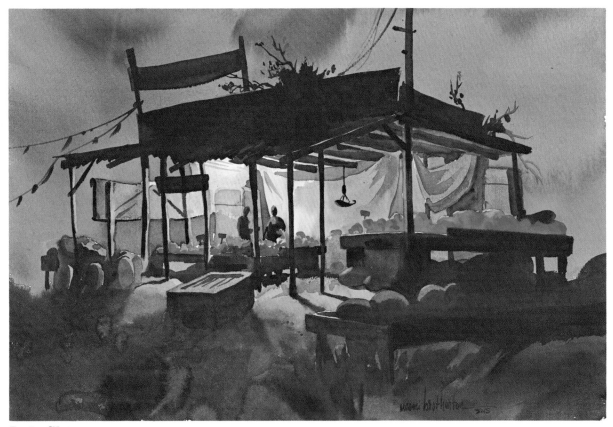

Late Shoppers

My original sketch of this scene based on a fruit stand in East Texas was done one afternoon in late summer. Back in my studio I revised it into a night scene. To accomplish this I first established the light source and painted in the brightest colors. Light radiates outward, diminishing quickly to darks as it goes. Notice how some things are painted in silhouette. The stand is an almost solid black against a dark blue sky. The boxes and nearby objects are also in silhouette, half hidden in mystery, as is the way of the night. The bedspreads hanging from the ceiling work as a backdrop to reflect the warm light near the center of interest.

The secret of success in a night scene is in the contrast of the lights and darks, and in the gradation of the light moving from the light source outward. Indigo blue is a great color with which to establish darks. It is transparent, but can be used in very deep tones. It will gray warm lighter colors to rich darks.

A Forward Look

Variations is a term usually referring to a musical theme repeated with modifications in rhythm, tune, harmony or key. The theme of this book is variations in watercolor painting. Just as there are many ways of doing almost everything in the world, so there are many techniques in watercolor. I want to share with you, not a way of doing something, but many ways of accomplishing similar goals. I'd like to help you explore the never-ending, always thrilling interactions between water, paper and transparent color.

Specific subject matter is utilized to lead the beginner to an understanding of techniques and variations in methods. The subject areas used in this book will include the following: water, trees, skies, mountains, foregrounds, buildings and flowers.

Watercolor paintings help you see possible variations. Each subject area begins with pictures and detailed explanations, so the novice will find instructions easy to follow. Each subject area also includes more complex pictures, leading the more advanced artist into a study of good design principles, including a variety of methods in editing paintings. Design principles are discussed throughout the book. They are brought together in a concise summary in the section, *Variations in Design.*

In the final section, several master watercolorists reach into their own experiences and share not only a chosen picture, but also some of their thoughts about the art of watercolor painting, juried shows and award-winning pictures.

2 Variations on Technique

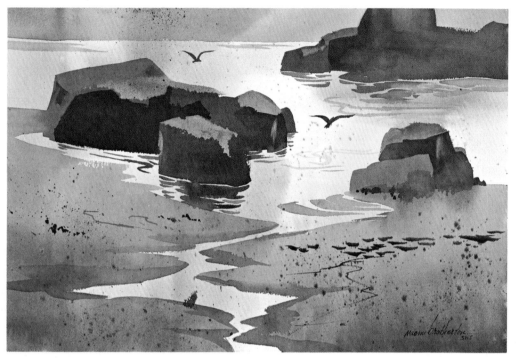

Tidewater

Luminosity of Water

Soft, flowing, lost edges of color suggest the feeling of a wet
reflecting liquid, and the transparency gives it luminous, glowing
light.

Actually, creating the suggestion of water can be very simple.
Here a wet into wet underpainting was used and allowed to dry.
The shapes, placement and values of the land and rock shapes
were carefully planned. The water was not touched after the
underpainting was dry, except for reflections. The dark angular
rocks contrasting with the flowing, transparent water help to
create luminosity.

September Morning

Rocks are solid, hard masses. They have form shadows and a light side to
give substance. Their shapes are usually angular. Their edges are often
hard and give the appearance of strength. In this case, both the individual
rock and the grouped silhouette need variety in shape, size, color and
value.

There are many rocks in this picture, and they are made in many
ways. A substantial amount of liquid paint was used to cover the large
silhouette form. It was left untouched for a brief period of time. How long
is this time? It depends on the amount and wetness of the paint as well as
on the humidity, but it is probably longer than you think. The inclination
is to proceed immediately. When the glisten begins to leave the paint, it is
ready. The light edge and top light may be lifted with a thirsty brush. Wet
the brush thoroughly and press out the water with the thumb and fore-
finger. Apply the brush to the desired area and lift off the color.

An old credit card, bowl scraper or a palette knife may also be used to
scrape a light shape into a wet wash. If the paint bleeds back in, you are
going at it too soon. Learning the correct timing is probably the most

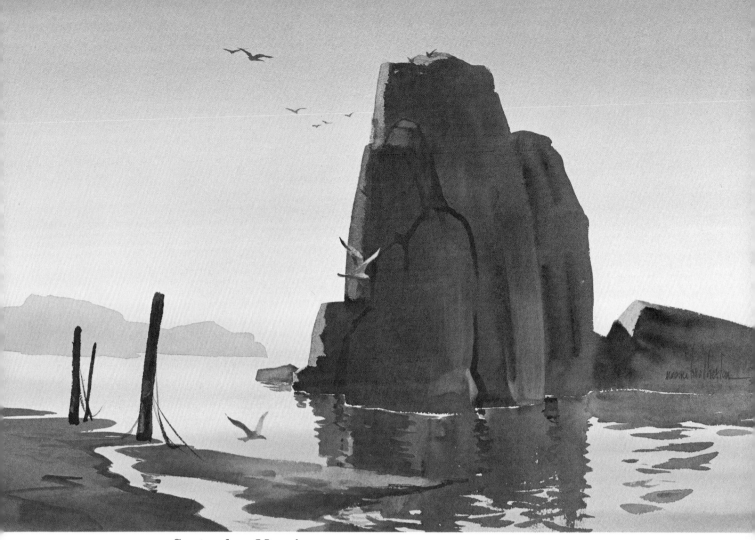

September Morning

crucial element in watercolor painting. And there is no way to tell you exactly how much time each maneuver requires. Experience is the only answer.

Other rocks were painted by applying a good substantial but transparent color over a silhouette, allowing it to dry, and then overpainting it with a darker shape.

The distant rocks require a strong, cool silhouette shape with very little surface change.

Here is the way *September Morning* was done. First, a wet into wet underpainting of the sky and water was layed in. A drop of very light New Gamboge was used at the horizon line. While still wet, a small bit of Winsor red was added. Winsor blue, slightly grayed was washed in, turning the picture upside down to paint the sky, deepening the wash with more color and less water as it approached the edge of the paper. The picture was turned upside down to keep the darker blue at the edge of the paper and to keep the paint from running down into the lighter colors at the horizon. After the wash was dry, the rocks were painted. Some of the light color appears below the far away silhouette to give a sense of distance. Note the placement of the verticals and the placement of the birds. They add life and tend to pull the eye into the painting.

The water was left untouched except for the reflections. The sky was also left untouched. Every time you paint over an area you lose some of the transparency and some of the luminosity. Avoid such loss as much as possible.

Water: Underpainting - Wet into Wet

*T*echnique is simply a method of accomplishing a desired aim. Artists invent and develop their own methods and procedures to create appealing effects. I like using an underpainting, wet into wet. You'll find this approach in many of my pictures.

As a support, I recommend you use a tempered masonite board because it will not absorb much water, and it helps keep your paper moist. Varnish, shellac or contact paper on the board further turns the water back into the paper. It also helps keep the masonite board from buckling. On this board, wet a piece of heavy watercolor paper (I usually use Arches 140 lb.) on both sides with a thoroughly saturated sponge. Dry areas in the sponge can scratch the paper. A good grade of watercolor paper is important. Not only is it a joy, but it is half the painting battle. For beginners, a fourth sheet (a full watercolor sheet cut into 4 equal parts) is less of a problem, a half sheet is about average size for most pictures, and a full sheet doubles the challenge.

Allow time for the paper to absorb water. If bubbles form, it is because there are dry spots underneath. Lift the edge and wet both the underside of the paper and the masonite board with a sponge. In demonstrations, artists usually find a way to talk while the absorbing process takes place, so students may not realize that there is a definite waiting period. When you lift the corner and it falls limp, the paper is ready.

Fresh pigment is important. Paints should be squeezed onto the palette from the tube at painting time so fresh color is available at its darkest value when you need it. One caution is important. Fresh paint can adhere to the bristles on the brush and make a permanent line on the paper. You can avoid this difficulty by carrying your brush from the paint to the palette, massaging it well, making sure that water and paint are distributed in the brush. Less paint and more water is used for light values. Dark values are gained by squeezing the brush to remove the water and by using more pigment.

When the paper has reached the proper limp stage, lift off the excess water with a thirsty sponge. A thirsty sponge is one that has been

thoroughly wet and then squeezed as dry as possible. If you use a brush, do not pull the bristles; just squeeze them gently.

Select your own color scheme by using the disks and the color wheel explained in section one. Remember you can use great variety in values and intensities, but only the colors you select in the color scheme. Work for directional dominance: a vertical dominance, a horizontal dominance, or an oblique dominance. In other words, the main shapes, forms and values in your picture create a visual thrust in a desired direction. Keep the paint soft and fluid. Try to avoid hard edges in your underpainting. Strive to maintain a color dominance. The color and directional dominance are vital to good design. As you paint, check that the edges of the paper are covered. It is usually advisable to hold corners and edges in a middle value range to help avoid drawing the eye away from the center of interest, either with compelling white shapes or strong dark values.

The design of the picture need not inhibit the underpainting. At times, I actually find it better to plan the design while the underpainting dries. For this reason it is best not to make the underpainting too strong. However, remember it will dry lighter, and you do not want washed-out pale colors, either. Experience is the best teacher in this area; maybe the only teacher. Do not overwork the paint. Try to float in the color, barely touching the paper with the brush. If you keep going back in, you will lose the luminosity. Keep it high key and brilliant with light, glowing colors so you do not commit yourself at this point to overpowering darks. Try to first establish an abstract, soft, fluid arrangement of colors. Some artists like to paint several underpaintings at one time, and just let them dry and keep them ready for use.

The real pleasure of working in watercolor comes when you feel a partnership with pigments, water and beautiful paper. As the underpainting dries, you can often watch watercolor itself become the artist. Beautiful things happen over which you have little control and for which you deserve little credit. The nice thing is the watercolor medium never complains when the artist modestly accepts credit for lucky accidents.

Stretching Paper

I usually stretch my paper at some point in the painting process. Sometimes this is done first, allowed to dry, and then rewet at painting time. Sometimes I paint wet into wet first with both sides wet, and then stretch the painting. The stretching process is the same at whatever point you do it.

Not everyone feels the need to stretch the paper, but it assures a flat surface on which to paint and a flat picture to frame.

A smooth surface plywood board about three-quarters of an inch thick is an excellent base for stretching paper. It is light weight and will not buckle when wet. It is also soft enough to accept light weight staples. Many artists like to place a sheet of rag paper on the board or a piece of plastic. The purpose of this is to keep any acids and other properties in the board from seeping into the watercolor paper.

In any event, the paper to be stretched should be thoroughly wet on both sides on a masonite board first and allowed to stand for about five minutes. Carefully lift your paper from the masonite board and lay it on the stretching board. It should lie flat and limp at this point. If you place it about three inches from the bottom of the board, it makes it easier to stand the board upright and place a mat over it for editing at different times during the painting.

The next step is to staple the watercolor paper to the board. Place the first staple in the center of one of the long sides and proceed to the corners with staples, each inserted about one-and-a-half inches apart and about a quarter-inch from the edge. It is best not to work with the stapler over the paper because the end of the stapler may come down and bruise the surface. Turn the board so the machine is outside the picture area. When securely stapled all around, lay the board flat and allow the paper to dry completely.

The mounting board should not make an imprint on the paper. Sometimes this happens and it is called "photographing." For this reason I use mahogany plywood, although "photographing" should offer no problem if you use a paper or plastic cover sheet already mentioned. When your painting is completed and dry, the staples can be easily removed with the point of a knife or a small screwdriver.

Perspective

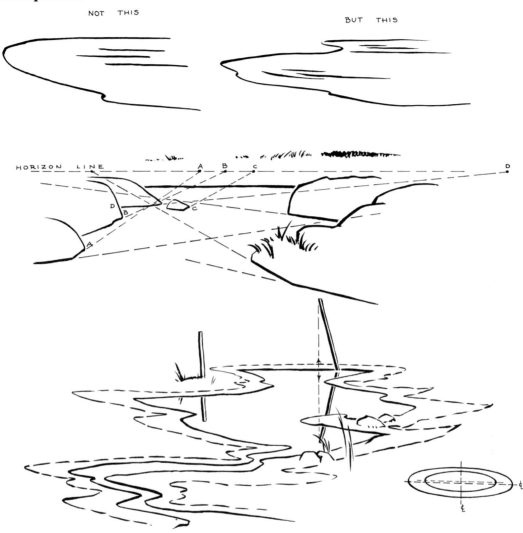

Charts on Perspective

The horizon line is always at the artist's eye level. A vanishing point is a point on the horizon where parallel lines meet.

Water will lie flat if it is drawn or painted in perspective. The back is straight and the sides recede to a vanishing point on the horizon.

In the top right hand example, note how the water appears to lie flat even if there is only a slight perspective.

In the detail of the second chart, follow the dotted lines to the horizon to understand land and water in perspective. Water is flat across the back and the receding banks go to different vanishing points.

The bottom drawing illustrates the bank and the angle of the reflections in the water.

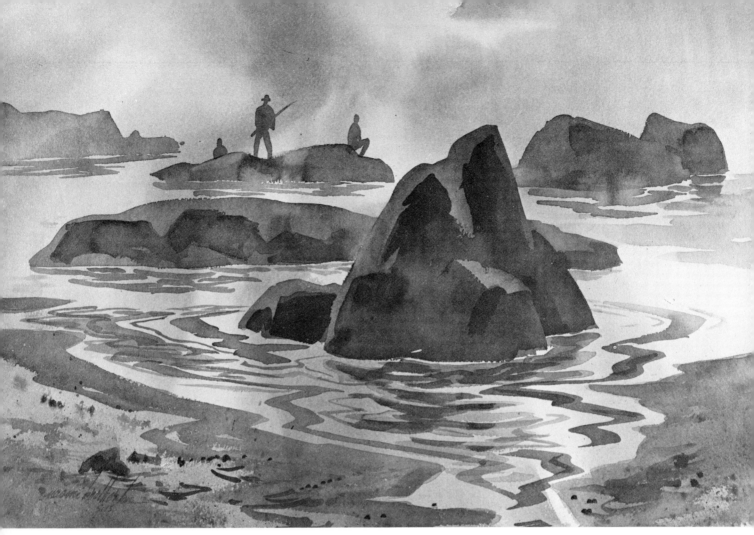

Fisherman's Cove

Reflections

In these paintings, for the most part, the water, as established in the underpainting, remains untouched to maintain its glistening transparency. Reflections say *water*. Reflections are always straight below the thing they are reflecting. Leave a thin, unpainted space between the rock and the beginning of the reflection. Uneven, horizontal strokes denote the slight movement of the water, but nonetheless they appear vertical in shape.

In *Fisherman's Cove* notice the treatment of the silhouette shapes of the distant rocks and figures, the variety of rocks and textures, the dominance of color, the transparency of water, its movement and repeated sky shapes in clear transparent color.

Figures in a picture usually command the center of attention, even though they are small and distant. They should be placed near a center of interest where something is happening. Don't pull the eye to a spot where there is nothing to see. A problem many beginners have is that they make the heads of distant figures too large. Make the shoulders of a man appear strong, but keep the head small. Remember the crotch should be at the mid-point of the body, so legs should be made fairly long to look correct.

What is a Good Shape?

Over and over we hear artists say, "Make good shapes. Make interesting shapes."

What is a good, interesting shape? A good shape should meet these requirements: Its dimensions offer variety, i.e., it is not a square, but longer and narrower in one area than in the other. It is not a circle, but elongated, and the further away from a circle it is, the more interesting it likely becomes. Often it serves best if it is placed at an angle. Such positions if pronounced are called *obliques*.

It is protruding and receding in uneven intervals along the edges so that the surrounding area flows into it, and it has interplay in spatial relations with its surroundings. It is like a good shape of a jigsaw puzzle. This interchange is called *interlocking*.

These guidelines are the same, both for the positive shape, which is the object in the picture, and for the negative shape, which is the unoccupied space between objects, such as sky, grass, etc. Even shapes of houses and other man made objects can be turned and grouped to achieve a variety in contour and interest in silhouette.

Planning a Painting

Planning a composition is essential because every picture presents multiple problems. Beautiful passages can be achieved accidentally in watercolor, but a good painting does not just happen.

The casual viewer, looking at *Fisherman's Shack* (pg. 40), will see a nostalgic water scene reminiscent of some bygone visual experience. He may like the picture because it makes him feel good, but beyond that he cannot tell you why he is attracted to it. On the other hand, an experienced picture observer notes pleasing shapes, intriguing interlocking values and pleasant colors organized into interesting relationships. If all these conditions exist the picture can be said to be well designed. Seldom is an unplanned composition well designed.

Some artists like to begin painting with no specific detail in mind. Then, as the color flows, they look into it and see a design forming. From this point on, good planning is vital to bring the design into focus.

Lights and darks must be especially controlled. Once the whites are destroyed in watercolor, they can never be restored in their full splendor. Shapes, both positive and negative, are more easily handled, but they all require careful consideration. Once you put down a line, a shape, or a color, everything else has to be considered in relation to it. This planning not only takes place before the painting begins, but it must also be an on-going process the artist thinks about every step of the picture-making procedure. Every shape or line influences every other shape or line. Every color changes with the colors placed beside it. The artist must think, plan and adjust with every stroke of the brush.

From My Sketchbook

Most often on location I simply do a small value sketch, recalling good shapes and points of interest. This tree has been a subject used in many pictures. It keeps showing up in all sizes, colors, and values imaginable.

Sketch of Location

Nature is a great artist. Her shapes are never monotonous, and the negative spaces always have variety. However, seldom does nature provide the best picture design complete within itself. There is too much to see. The artist's interpretation is imperative.

A camera can be important in supplying detail, but I find sketches done on location are much more valuable to me in recalling reactions and feelings. The sketch suggests why I thought the scene was exciting or beautiful.

The sketch shown here was done with ink and brush on a full sheet of watercolor paper. It seemed to satisfy my need to respond to the

beauty about me. I may paint it someday, or more likely I may plan a dozen paintings from it, using different points of emphasis. Perhaps just a tree or some other area will be used as the basis for a wholly new composition.

My color schemes are not always nature's hues. The disks and the color wheel give exciting departures from tradition. A painting, after all, is not nature as it exists, but my interpretation and reaction to what I see. In almost every case it is up to the artist to supply color dominance, directional dominance, and contrast. Seldom are these considerations fully formed in nature.

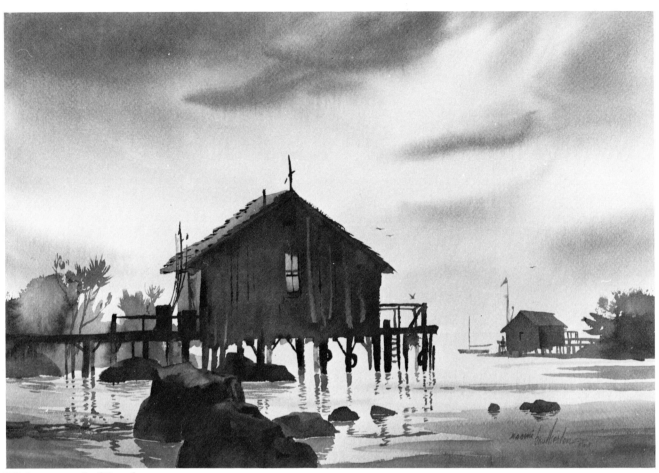

Fisherman's Shack

Let's examine the design in this painting. The darkest darks, consisting of the shack and pilings, are not in the center of the page, either horizontally or vertically. The piles, touching and extending the darks, make a shape, longer than wide, with many protrusions reaching out and interlocking with the surrounding area. This dark shape is strategically placed in the lightest area of the sky, with the soft wisps of clouds gently directing the eye to the strong value and color contrasts.

The middle value shapes at the sides also offer variety, and serve as a *stop*, keeping the observer's attention within the picture. The rocks in the foreground touch the dark piles to further elongate this shape and hold the attention in the area of interest. Note how the pilings are of somewhat different shapes, with uneven placement to help break up the negative space and offer variety.

None of these things just happen. They come from planning and from *thinking about each shape before and while you paint*. Much variety of color and value exist even in this picture which consists chiefly of warm and cool grays and browns.

When a painting has correct values, interesting shapes and pleasing color, little else is needed to make it complete.

There is always a lot of extraneous material around most areas of human activity. Cluttered around this shack was a lot of fishing gear. It served well to create interlocking edges. The fishing poles leaning up against the building were done by dipping the edge of an old credit card in pigment, pressing the curved card in place. Avoid making any two alike.

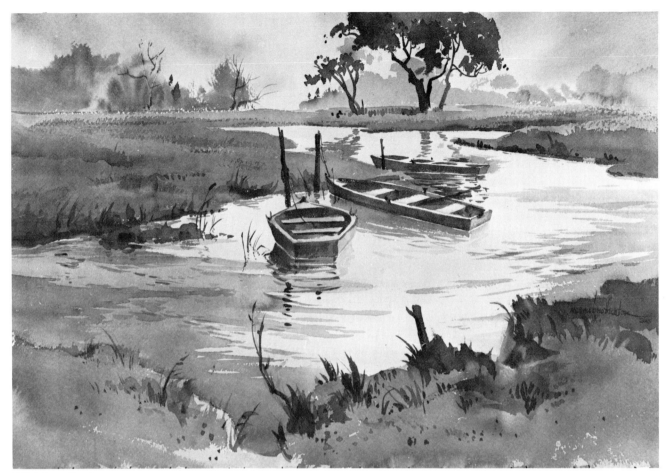

Hidden Lake

Color of Water

This picture is an example of inland water with horizontal lines at the back to say, *flat water*, and with banks coming forward in perspective. The water mirrors the boats, picking up the same colors and inverse shapes. The water also takes its color from the sky and reflects the cloud shapes. Usually it looks warmer as it comes forward. The front grasses carry warm reds, red-orange, and warm deep greens.

The blurred silhouetted shapes of the distant trees help to establish a feeling of distance. This atmospheric area is contrasted by the single tree in the middle ground. Here a bit more definition and contrasts bring it forward. The high horizon makes for good space division. A bit of calligraphy to add texture in the foreground completes the painting. The color scheme is a split complement—red, blue-green, and yellow-green.

Editing Your Painting

The word *edit* means to alter, adapt, refine, or to bring about conformity to a standard. The process of painting includes editing the picture, not only when it is finished, but at many stages throughout the painting. To edit, it is vital that you know the standards you are striving to meet. Understanding of what is good makes it possible to preserve it. Understanding of what is weak helps you make alterations and adjustments. Many people think it is impossible to change watercolor paintings. This is far from accurate. Changes can be made at many different times.

Perhaps the main problem beginning watercolorists have is that they do not stand off and look at their paintings enough during the painting process. Even advanced painters might profit by more *looking* at a distance. It is especially difficult to see the parts of a watercolor painting in their true relationships because the wet paintings must lie fairly flat so the water-soaked pigment won't run in uncontrolled directions.

In my studio I have hung an 18 x 24 inch mirror in back of my shoulder at a 45-degree angle, so it will reflect what I am painting on my table. Often during the painting process I turn to examine the painted shapes in the mirror. It is amazing how much easier it is to see poor shapes and problems when you look at them reversed in a reflection. The mirror doubles the viewing distance, pushing it away from you so shapes, values and details assume a proper viewing distance.

It is important to turn the picture upside down and on each side. A good shape and a good design will read well in any direction. When

shapes don't work well it is more apparent when they are seen upside down and out of a realistic framework.

A mat makes the picture area easier to see and it can help you in controlling the design. Study your shapes and relationships with a mat on the picture. As mentioned earlier, when I stretch and staple my paper to my support, I place it three inches from the bottom of the board. When editing the dry picture, I am able to stand the board against a table and place the mat in front of it. A mat also isolates the picture from its surroundings.

For me, as the picture nears completion, the editing process continues over a several day period and sometimes over several months. At first I am too involved to see problems, so I leave the picture, get away, even forget it. When I come back to view it I have a more objective viewpoint. Sometimes I discover passages near the edges that draw too much attention. I hate to overpaint an area even lightly because it will destroy the brilliance. So I examine the painting carefully for a time. If my eye keeps going back to that offending area, it will have to go. It is pulling the eye out of the painting, attracting undue attention. To overpaint it may sacrifice some of the brilliance, but that is a price you must pay to preserve the design and interest within the picture.

Editing is not a process of admiration. It is an active examination of each section, each relationship, each color. The biggest problem is to know what to look for and how to see.

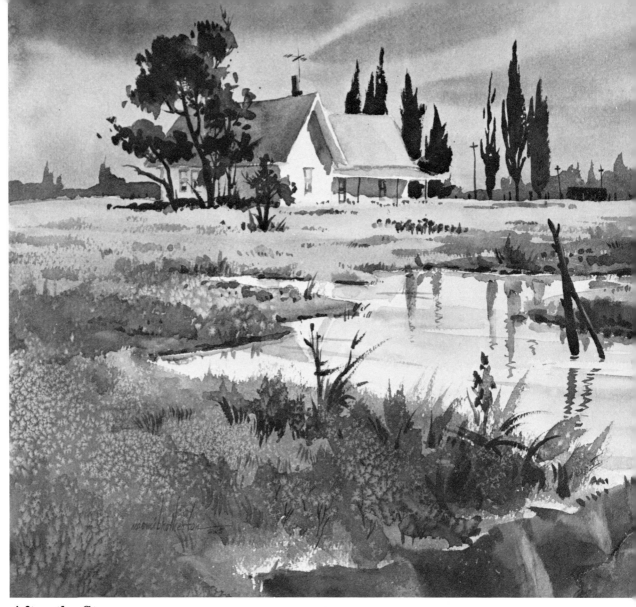

After the Storm

Editing is bringing about conformity to a standard. The standard is good design. Apply the following steps first to the picture, *After the Storm*, and then to your own painting. The double application will aid in learning to edit your work.

Check space division to see that the horizon is not in the middle, and that objects are not equidistant from two edges. Unequal space division is the first step in good design.

Judge the shapes by the standard for a good shape: oblique, two-dimensional, and interlocking.

Check shapes for variations in size, color and value. The subject matter may be abstract or realistic, but the same tests apply.

Examine the center of interest. See that it is not in the center of the page. Determine that the dark and light values in this area are as dramatic as possible. Actually, the eye and mind cannot comprehend a painting all at once. The eye likes to wander over the beautiful mid-tones, but the center of interest must keep pulling the eye *into* the picture, or the viewer goes on to other things and other paintings.

Avoid monotony. Create variety—variety in color, variety in size, variety in shapes, and variety in values.

The clouds bespeak a storm, but washed greens and the warm reflected light on the house and under the porch say that the storm has passed and that rays of the sun are beginning to light the house, the trees and the water.

The house should not sit on the horizon line, and the house and banks of the water should be in convincing perspective. In this picture the house is too far back to get a mirror reflection.

Note how little detail is needed to complete the picture. Contrast is great between the dark mud banks and the light water; between the green of the roof and the warm red in the foreground; between the vertical post and the soft

obliques of the water; and between the cloudy
gray depths of the sky and the white house
lighted by the sun and surrounded by dark trees.

The directional dominance is basically hori-
zontal, with relieving verticals in the form of
trees, posts and uprights on the house. Some
oblique movement is evident in the shape of the
water and banks in the foreground. The color
dominance is green, with many variations of
warms and cools, of darks and lights. The
textural effects apparent in the foreground grass
were done by sprinkling salt onto the wet surface.

Study your own pictures until you know
exactly what you want to do and why. Then do it.
Here is where you must have courage. Don't just
pick around, not knowing what or why. Study the
painting until you know. Then make every brush-
load of paint count.

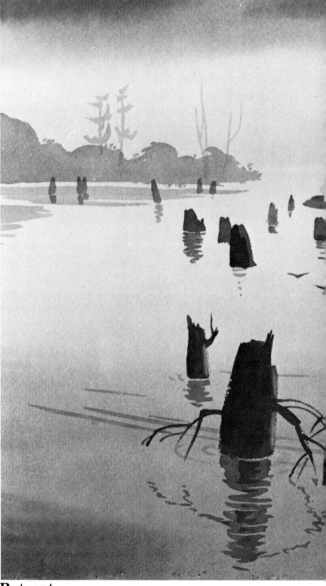

Retreat

Water as a Graded Wash

In this picture I like the transparent rose glow played against grays of many values and many hues. The grays are a mixture of indigo and brown madder, sometimes neutral, sometimes warm and sometimes cool.

The first step was an underpainting beginning with a light band of New Gamboge straddling a high horizon with a light Winsor red floated into it. The sky was completed with a graded wash, and the clouds were added last, just before the glisten begins to disappear. The water was a graded wash in reverse to the sky with

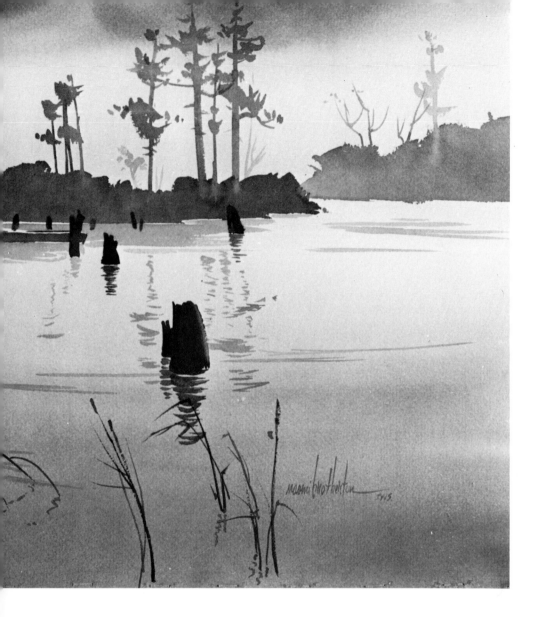

warm clouds reflected in the foreground. The
wash dried completely before the land shapes,
trees and stumps were painted.

The values of the grays are important. The
distant headland should not cover all the orange.
It should appear both in the sky and in the water.
The distant trees break up the wide expanse of
negative space with interesting shapes, both in
the positive tree and in the negative space. The
stumps represent a gradation: in value, becoming
darker toward the front; in color, becoming
warmer as they come forward; and in size,
becoming larger in the foreground.

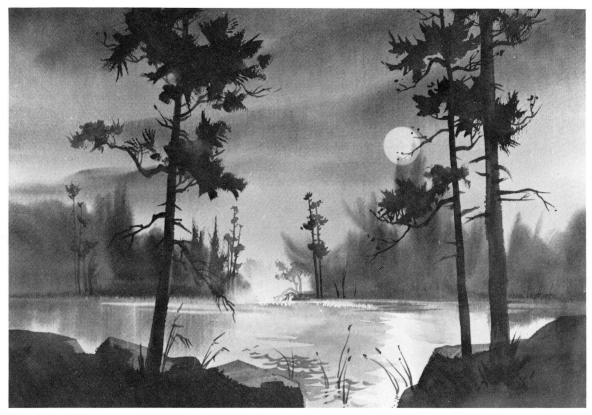

Evening Blues

Color, light, sun and shadow lend an exciting dimension to any watercolor. But the night gives a mystery and splendor all its own. The palette for this painting was indigo, brown madder and Winsor blue.

The first step was an underpainting, wet into wet, of the sky and water in reverse, carefully covering the edges of the paper with dark midtones and keeping the lights toward the center. The low horizon helps to establish good space division. The values are dark enough to read as night, but luminous and transparent, not dull and opaque.

The deckle at the edge of the paper can hold water and cause blooms and backruns. When this happens, keep mopping up the water with the tissue. It helps to keep your board of stretched paper propped up slightly so puddles will not form and cause backruns, and so the flow will be in the same direction. For me, the slant is best at about 10-15 degrees.

The streak of reflected light in the water was quickly wiped out with one stroke of a sponge while the paint was still wet, just as the glisten was about to leave the paper.

Allow the underpainting to dry. As it dries, study it. If the values are not deep enough to say *night*, then perhaps you should try again. Think about and plan your shapes for the distant trees, nearby rocks, and foreground tree shapes. When it is completely dry, use a circle mask or stencil. Place it in the best spot in the sky over the streak you wiped out, and with a damp sponge rub out the moon shape. Not too much, just right, with slightly indistinct edges!

The values of the distant trees read as darks, with some variations of warms to cools. The shapes have variety. Make up your mind what you want, mix a deep value, vary it with every brush stroke by adding more brown madder here and more blue there. Work on dry paper, carrying your water in your brush.

Washes can be painted over the water without touching the white streak. More thinking than painting is usually required in finishing a painting. A few details strategically placed is the secret.

At certain times reflections cast themselves across a vast expanse of water. Sometimes they are a mirror image, but most often disturbances on the water wipe out the reflections in interesting shapes across a lake or pond.

After the underpainting was dry, the background shapes and the clumps of trees were painted. The mood of the picture is subdued but cheerful. The trees are greens, warmed by yellows and reds at the edges. This variety was accomplished by painting the silhouette of leaf shapes and then by dropping in colors at the edge while the paint was still wet.

After the trees were dry, the blue wash in the water area was painted. While these washes were still wet but dry enough to hold a soft edge, the reflections of the trees and trunks were dropped in. The foreground was kept wet and a warm blue and the reflected leaf shapes were painted into the wash. The luminosity of the water depends on the streaks left untouched. If the streaks are not in proper perspective, they will not appear to lie flat. The tree trunks and leaf shapes were designed to make interesting patterns.

Summer Solstice

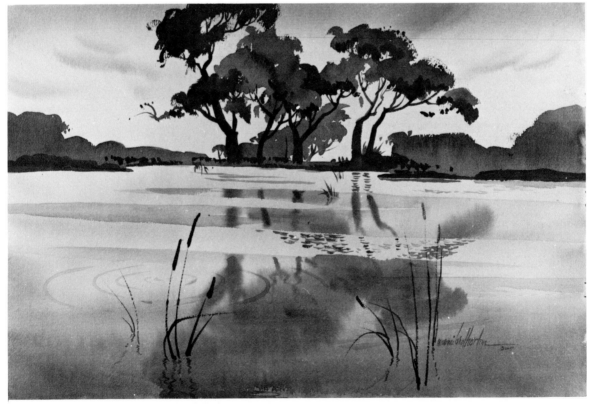

3 Trees

Variations on Techniques

With their stately, statuesque quality, trees represent a majestic aspect of nature, and no artist can long paint landscapes without meeting the challenge of painting them. Moreover, trees embody the essence of good design. There is beauty of line against masses and pattern. Curves are contrasted with straight edges. Dark and light values display strength, rhythm, grace and dignity. Trees come large or small, but always with an exciting shape and silhouette.

First, become acquainted with your tree; the one you want to paint. Trees are no more *trees in general* than people are *people in general*. Each tree is an individual, and has its own gesture, grace and personality. This is not to suggest the obvious that there are differences between oaks and elms. Rather, what you should note is that each oak is an individal and is best portrayed as different from every other oak or elm.

Value Sketches

Some watercolorists begin painting and planning as they go, allowing the accidents of the medium to suggest a direction. But, for many the planning stage is an important first step. I like to use four values: light midtone, dark midtone, black and white. My favorite drawing pencil is a 6B flat General Sketching Pencil. With a chisel point it is like using a brush.

The small upper right drawing (opposite **page**) is not a value sketch. It has only two values instead of four and leaves too much white. The light shapes are not defined. These sketches are quickies, made to the proportion of a full sheet or a quarter sheet of watercolor paper. Value sketches allow me to begin painting with an understanding of where I want my lights, darks and midtones. I often make such sketches to pass time while I watch TV with my family.

It is also helpful at times to work up larger, more detailed sketches (page 52). These sketches depict essentially the same trees with different lighting and varied contrasts. Either might be painted, but the mood would be different. The direction and path of light and its relation to the values are decisions made in a value sketch.

Leaving a white border on the value sketch gives the effect of it having a mat, and this helps in studying the value relationships more closely.

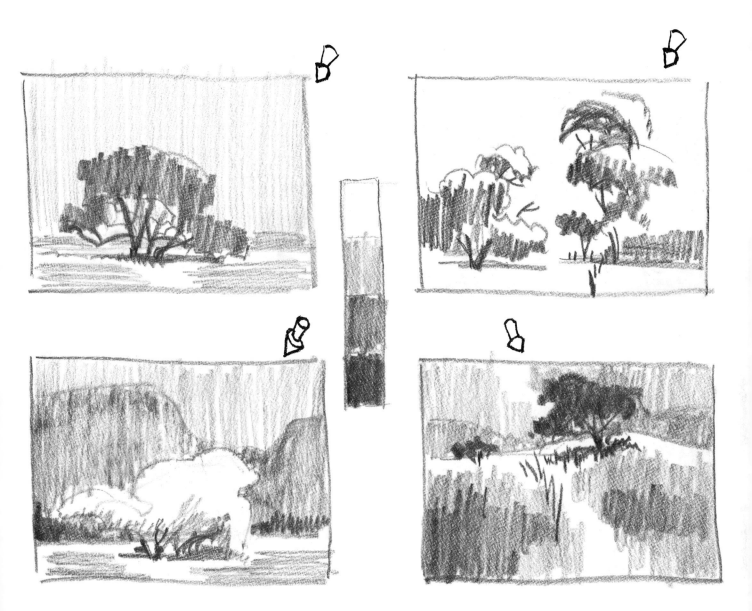

Painting From Value Sketches

This dominantly warm painting has an analogous color scheme, going from yellow-green to orange. The palette was indigo, New Gamboge, brown madder, Winsor red and Winsor green.

 Without drawing first, I painted on dry, already stretched paper, carrying enough water in my brush to make a nice, juicy liquid. Sufficient pigment is also needed in the brush to keep the paint from appearing too pale. Painting directly on dry paper makes it easier to judge the value because colors will not soak in as much as when the paper is thoroughly wet.

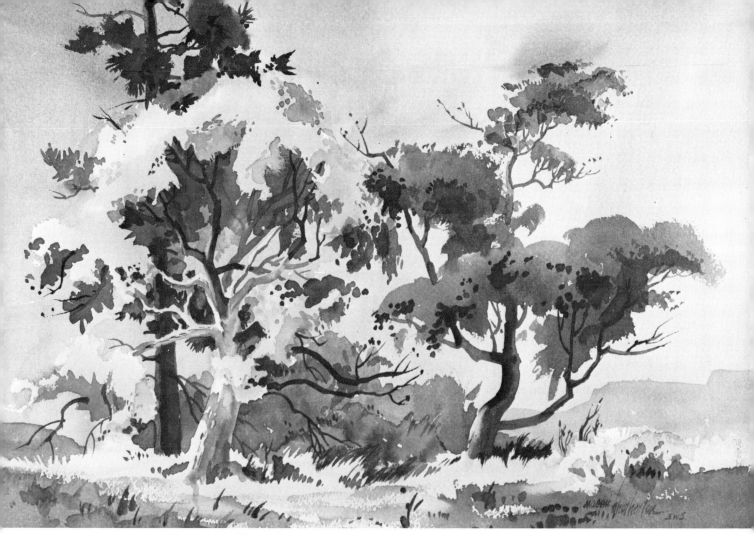

Autumn Signals

As you paint, think about the shapes you are creating. The shapes are particularly important here. Because of the similarity in size and contour they could easily become monotonous. Think value change and color change with every brush stroke you apply. I first shaped the yellow-green foliage so it would be bright, and not dulled by underpainting. At the same time, some of the yellow-green with color change in the ground for a repeat of color was added. Then I wet the sky area with a brush, going around the yellow-green foliage with just a bit of overlap for shadow. Indigo and brown madder were mixed to make the grays for the sky, sometimes very warm, sometimes cool, and at times neutral. A color surrounded by a darker hue will appear lighter than the same color with different association. For this reason, the sky was darkened somewhat where I expected to paint sky holes, places where the sky shows between branches and masses of foliage. A bit of the sky color is repeated in the grassy foreground.

Nature's Green

If you examine the green outside in summer, it'll probably seem green — just green. If you look closely, however, you will see that it is made of many shades of green, mostly warm. Using your favorite pigments, mix a green that says foliage to you. Then go outside and pick a leaf and compare it with the green you mixed. Most people discover on doing this that their green is not nearly warm enough.

Green in nature is often a lot more red than you think at first. The drab olive green worn by the army and marines shows that the military knows what they are doing when it comes to camouflage. Their green is very warm. Tube greens are seldom satisfactory by themselves. Winsor green is a good example. An examination of the color will reveal it to be cool blue-green. If you mix yellow with it, it is still a cool green, not nature's green. Winsor green and reds (especially an alizarin crimson), when mixed make deep gray green and even a black, but the two colors tend to separate when used wet into wet.

Mix Winsor green and New Gamboge to a bright green and then add burnt sienna, brown madder or Winsor red until you have a warm olive green. Thin the mixture with water to a medium value and you will have a good green for foliage and grass. Winsor green and pthalo green are different labels for the same color.

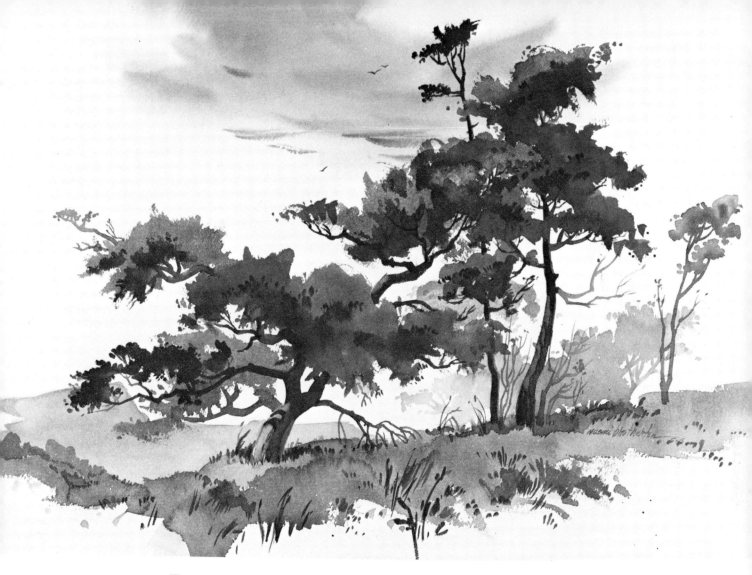

Treescape

Autumn is the glory time for trees. Their great shapes are brilliant in unmatchable color. Deciduous trees cannot be ignored when their leaves turn. What an eye-filling joy a walk in a park or down a country lane can be when the oaks, maples, aspen, et al, are glowing in their red and gold splendor. Neither sketches nor camera can equal the memory of the day, the walk and the mood.

Treescape, a vignette, is a study of good design shapes, both in the color and in the negative white paper areas which make up an important part of the design. There is a strong oblique thrust in the tree at the left, but this is balanced by the vertical movement of the other trees and the stabilizing horizontals of the clouds and the foreground area. A complementary color scheme of red and green was used with both colors being grayed and appearing in many shades and values. The palette was indigo, brown madder, New Gamboge and Winsor green.

The cloud shape was painted wet into wet, and the paper was then stapled to a supporting board and allowed to dry completely. The shapes of foliage were painted next, representing as they do, the big masses. The trunks and branches were woven into the foliage as drying began. Shaded sides of the masses and descriptive calligraphy were indicated last.

Wintering Willows

Trees have beauty under all conditions, even when they are bare and without foliage. The twisting and turning of the trunks and branches often create interesting shapes and values. Notice here how the trunks and branches going away from the viewer are cooler and of a lighter value, while those coming toward us are warmer, darker and more defined.

If you get too much angle on your tree, it will appear freakish. At the same time, if trunks are not somewhat oblique and interlocking they may appear stiff. Be conscious of different measures and shapes between the trunks and between the limbs. Do not cross limbs and trunks with a ∧ shape. You are likely to have a ∧ above and a ∨ below, coming out with an undesirable ✕ .

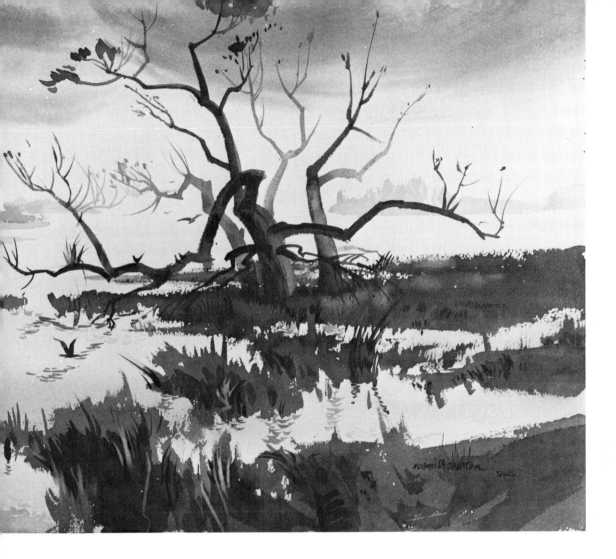

This color scheme is a split complement of blue, green and red-orange. The palette was Winsor blue, Winsor red, New Gamboge, brown madder and indigo.

First, on wet paper, the Winsor red and a small bit of New Gamboge were dropped in at the high horizon line. With gradation, a wash was painted with transparent, non-sedimentary, staining Winsor blue. The water is a repeat of the sky in reverse. The warm clouds reflecting in the foreground water were painted just as the glisten was leaving the paper, but while it was still wet enough to take the color and diffuse it into soft edges. At this point the paper was stapled to a supporting board and allowed to dry completely. When the dark pattern was imposed on the dry surface. The grasses hid the reflection for the most part. Broken water is suggested by wavelets indicating movement.

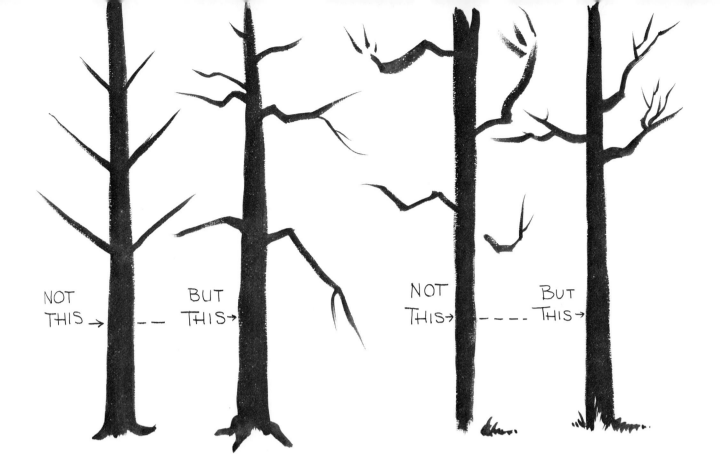

NOT THIS → — — BUT THIS →

NOT THIS → — — — — BUT THIS →

Common Mistakes

Limbs leaving the trunks should not be repetitious. In most trees, limbs are quite unique. Seldom do they grow from the trunk at the same angle or level or direction.

Some limbs and branches move up and some go down or out. Generally, they leave the trunk going up a little and then they often dip downward.

Branches and twigs should not appear to float in midair. They should be attached to the limb. Don't make trees bigger at the top than they are at the bottom. They are like a water system, large at the base, small at the extremities.

Roots are like the reverse of limbs. They leave the trunk and grab hold of the earth like fingers going down into the ground. The root system of many trees almost exactly balances the size and proportions of the branches and twigs evident above ground.

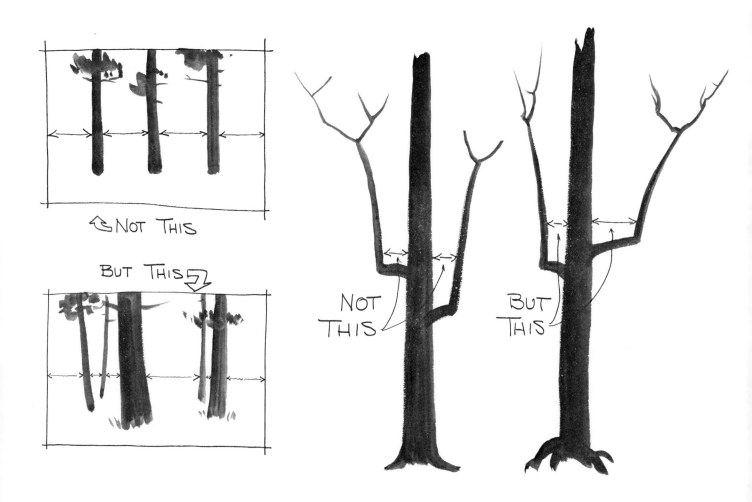

Points to consider:

1 Do not make the negative spaces between the trunk and the branches monotonous or repetitious.

2 Paint tree trunks of different sizes both in height and girth.

3 Vary the distances between trunks, and paint them growing out of the ground at different levels in the foreground.

4 Remember, branches grow out of a trunk all the way around the tree, not just on one side.

5 Looking at one side of a tree, some branches come forward and some originate from behind the trunk.

6 Lighter, cooler foliage will seem to be back of darker, warmer foliage.

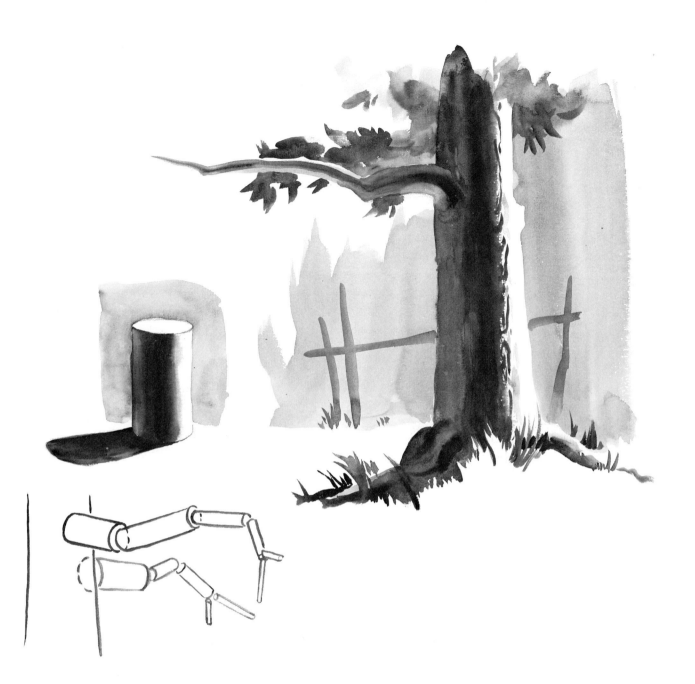

Form Description

The artist paints light as it strikes a form. A tree trunk is a cylinder, and it has form shadows to describe its roundness. Generally speaking, the side of the tree trunk where the light shines is light, and the side away from the light is dark. However, reflected light bounces into the dark side. The darkest part of the form shadow is not at the outer edge away from the light. The darkest part is at the plane change where the form shadow actually begins to turn from the light. Between the plane change and the light is a half tone. It is the transition between light and the plane change. It is the place where we most often see texture. Each little texture has its own shadow, making the texture more evident.

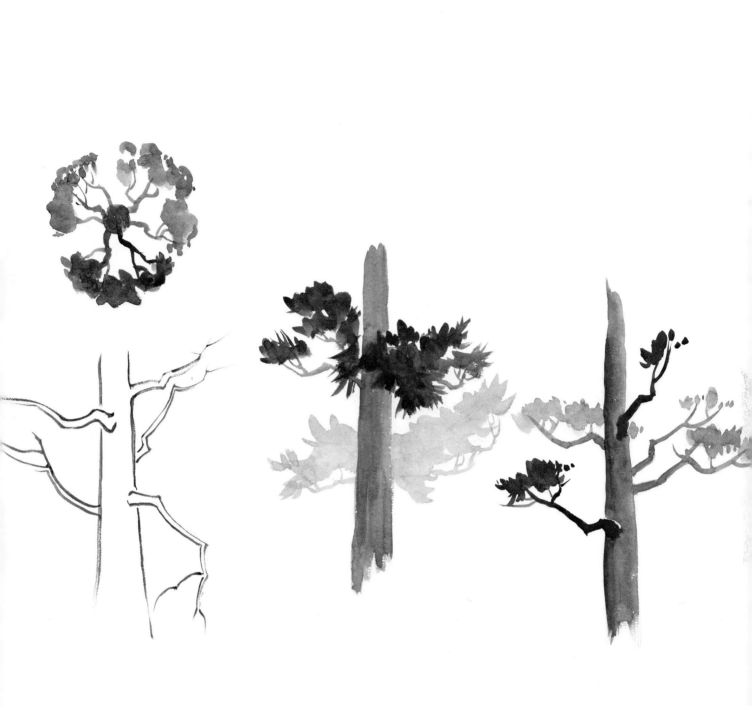

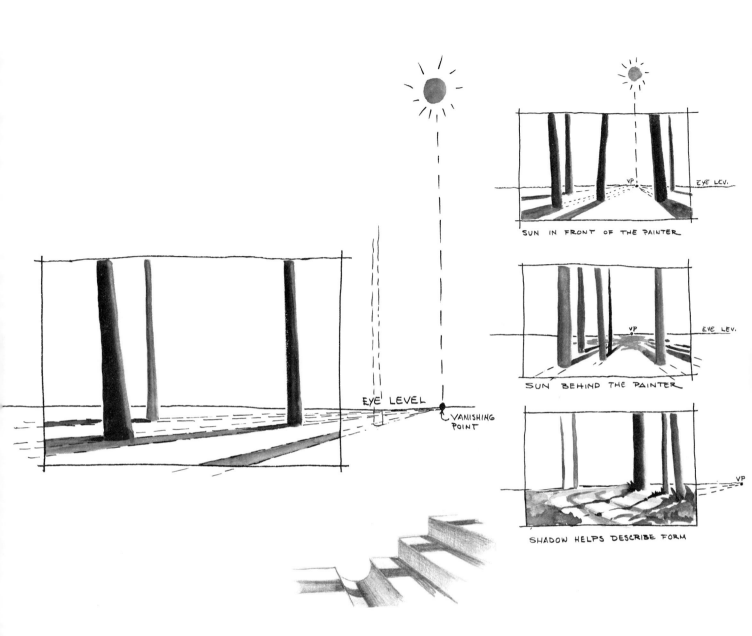

SUN IN FRONT OF THE PAINTER

SUN BEHIND THE PAINTER

SHADOW HELPS DESCRIBE FORM

EYE LEVEL

VANISHING POINT

Vanishing Point of Cast Shadows

The tree itself casts a shadow on the ground or on some other object. These cast shadows on the ground radiate from a vanishing point at some place on the horizon. Decide on the location of the sun and draw a perpendicular from it to the horizon or eye level. The cast shadows will be in line with that point on the horizon.

If the sun is directly back of the artist, the shadows of trees will lead directly back to the vanishing point as if the ground plane were viewed in one-point perspective.

If the shadow falls on uneven ground, the shadow will follow the contour of the ground and describe the form of whatever it crosses.

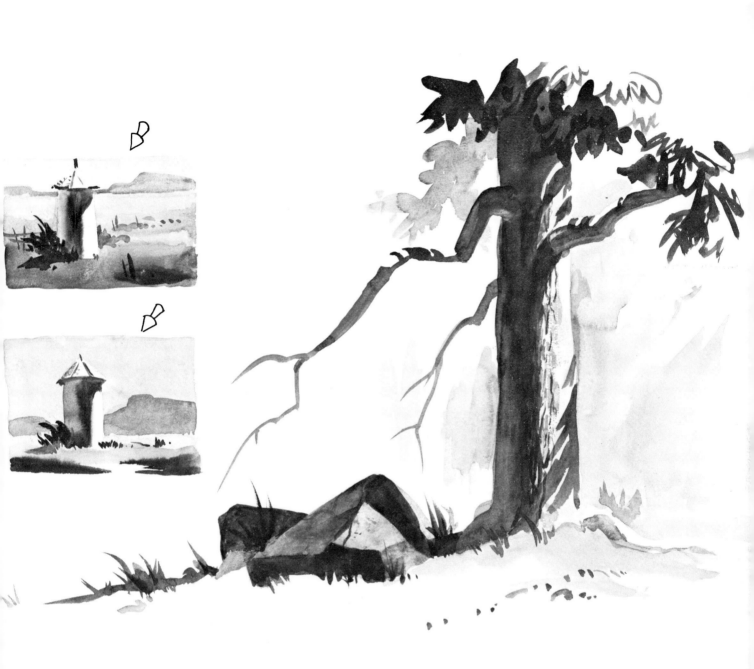

Cast Shadows

Shadows of other trees and foliage above also fall on the tree. If these shadows are painted straight across the tree, they will flatten out the trunk. Such cast shadows should follow the round contour of the tree on which they fall. In this way the shadow will help to describe the roundness of the tree.

Color Dominance

Color dominance helps create unity in a painting. A dominant color can be achieved in a number of ways.

An underpainting of the dominant color will glow through all other transparent colors used in the painting.

A glaze of the dominant color can be painted over the entire picture after it is complete, thus unifying all the hues.

A bit of the dominant color can be mixed into every other color. This chosen color sometimes referred to as the *Mother Color*, can pervade the entire painting, relating all the hues beautifully.

A dominant color can occupy the largest space area. It can be used in variations of tints and shades. It can occupy the most important position or size. It does not have to be the purest color. It can be grayed and of low intensity.

For the most part, all colors used in a picture are repeated and not isolated. An exception is a pure color in a small but important area as contrast.

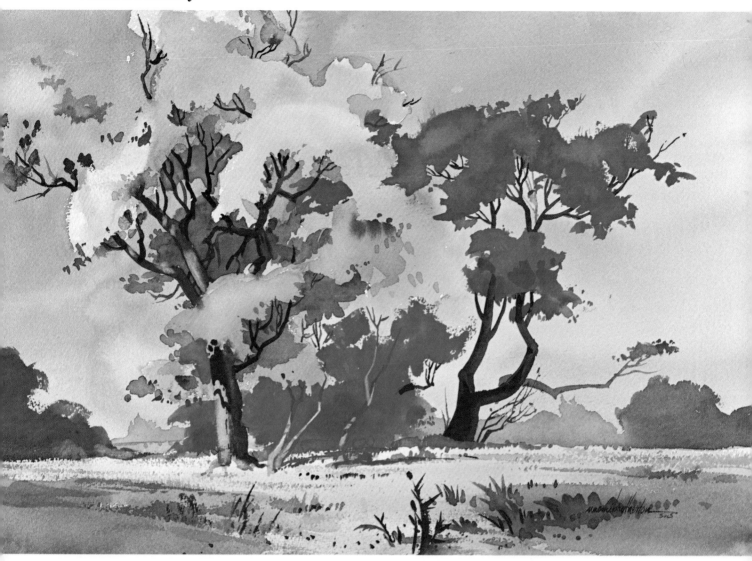

Important Leaf Masses

Techniques used in *Autumn Signals* (pg. 53) apply also to this painting. The dominant color here is cool. The blue dominates all the colors and also occupies a large sky area. A close look shows that the yellow-green was slightly wet when branches and trunks were painted. Although the ground area became warmer as it moved forward, the blue cast was not completely lost. There is even one blue weed, made with one stroke of the brush, in the near foreground.

The leaf masses are simple but significant shapes. Try painting them with the brush held underhand, i.e., the forefinger on top and the other fingers underneath. Apply pressure with the forefinger and release it for variations. Twist the wrist and arm to achieve interlocking edges while pushing outward from the center of the shape. I do not draw in advance, but create the shapes as I work.

The foliage shapes may be influenced by the sky area. For instance, do not paint over a part of the sky that is especially pleasing. If one part of the sky is flat, the foliage can cover it with an exciting shape.

The word *dynamic* is related to physical force or energy, and it is marked by continuous, usually productive, activity or change. Perhaps watercolor painting is best described by the words, dynamic creativity. The artist is dynamic, ever-changing. He looks at what he puts on paper as he paints, thinking shapes. Not leaves. Not trees. But shapes. He keeps analyzing distances, lines, directions, values, colors and negative areas. With dynamic creativity, with ever-changing originality, he keeps the vital elements of a picture in harmony and interesting relationships.

Tall Timber

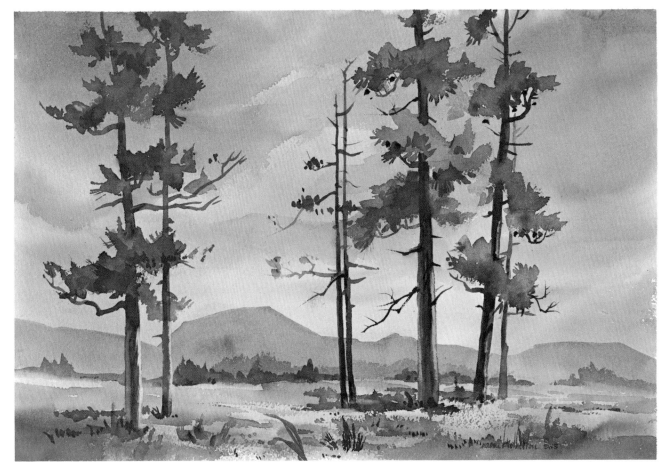

Tall pines lined up in a row present composing problems. Variety must be injected. Here are some of the considerations necessary to overcome a static, placid arrangement. By emphasizing uneven ground placement of the trunks a feeling of depth is achieved. Also, uneven size and shape of the foliage and branches lend interest. It is a test of one's ability to avoid monotony.

Obviously, the trees establish a vertical dominance. This is offset by the horizontal sweep of the hills and sky.

Because the foliage on pines is almost a grayed green, I used indigo, New Gamboge and brown madder, with a little Winsor green for variation in color. Many pine trunks are beautiful warms, almost orange.

Carefully make your trees round by lifting a light side with a thirsty brush while it is wet and by painting a dark at the plane change. Some pines have little pompoms at the edges of the stems, but do not paint as many as you can see. Otherwise they take on too much importance. Indicate only a few. The essence is in the silhouette shape.

Check that the trunks are not exactly parallel to one another or to the vertical edges of the paper. There is always an opportunity for interesting shapes in the branches and twigs, and they offer contrast in obliques and horizontals.

The Painting Process

Many painters make good value sketches. However, often when they begin to paint, they quit thinking creatively. They become a slave to their preconceived sketch. They are unaware of what actually goes on in productive painting. Water, paper and watercolor pigment make new demands at every stroke of the brush. Watercolor painting is a bit like skiing the giant slalom. Skiers practice hours on technique, they are in condition, they have the proper equipment. But, racing the zig-zag course seldom happens as planned. At every turn the skiers must think about how they are putting their weight down, being conscious of the exact demands of the snow on this particular run. They must check that their form is keeping them in good position, adjusting to the new demands at each gate.

Watercolor painting is like a race; when the paper is wet, it is a struggle with time and the special conditions of a given day. This active process of meeting new demands at every stroke of the brush is not something many amateurs easily cope with. They learn as they perform. Perfection comes only after many unsatisfactory starts.

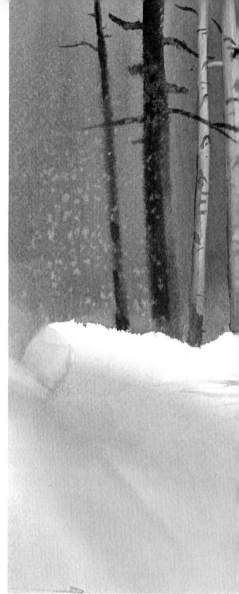

Ruidoso Pine

This entire picture was painted wet into wet. I worked on a masonite board using a front and back sponge-soaked 140 lb. Arches cold press paper. While waiting for the paper to become limp, I prepared my palette by squeezing out fresh pigment.

The color scheme is a semi-triad of green, red and blue. The pigments were indigo, brown madder, burnt sienna, alizarin crimson, Antwerp blue, Winsor green and New Gamboge.

When the paper is limp, excess water is removed from the top with a thirsty sponge. This allows you to gain control of the paper. Next, drop in a warm, light burnt sienna in the foreground. Everything is very wet, so the color will diffuse and leave a warm glow.

Mix indigo and brown madder to a good gray. As I paint, I keep warming the gray with brown madder in places and cooling it with indigo in shadow areas. Keep the liquid wet enough to achieve soft edges, and do not paint the gray to the edge of the snow shape. Leave some white paper untouched. With the same gray, paint the bottom shapes of the snow across the tree limbs.

A large amount of indigo and Antwerp blue is now mixed. It is warmed in some areas with brown madder as the sky is painted. Strive to keep the vertical emphasis strong and for a good variety in color and value. With the sky color, the snow on the ground is defined, leaving white where it picks up the light. The space for the big trunk and the shape of the snow on the trunks is left untouched by painting around these forms. Later you can come back and *lift* the shapes of the small trees, but don't do

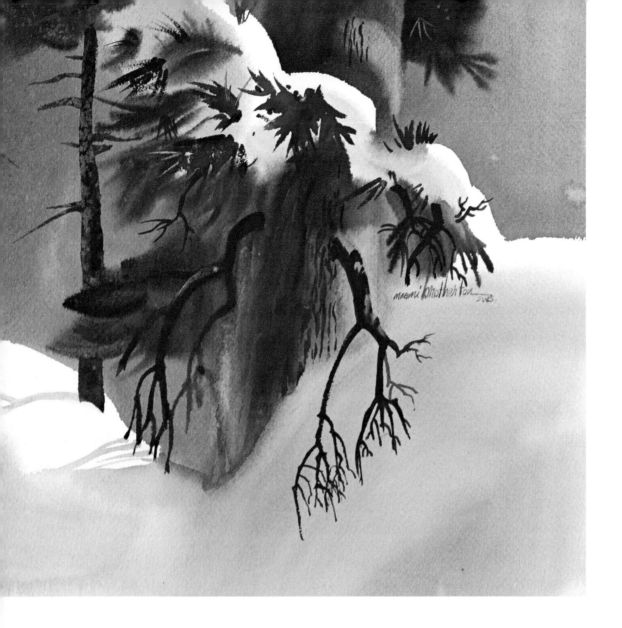

it at this point because the paper has been rewet so the sky could be painted.

Now, go to the big trunk. These colors are burnt sienna, alizarin crimson and brown madder with some indigo. The colors are applied and mixed on the wet paper. With a thirsty brush lift off additional lights for variety. As the upper tree is painted the snow across the branches is shaped.

Next we go after the small background trees—lift the color with a thirsty brush, creating variety in placement, size and shape. Maybe we can and maybe we can't paint in the dark trees at this point. If they can be painted with less water in the brush than is in the paper, it'll be O.K. However, if the paper is at a certain stage of dryness, but not completely dry, extra water in the brush will cause a bloom. Test it to make sure. You can lift the light trees after the paper is completely dry. Use torn edges of old watercolor paper or of any good paper. Place the torn edges side by side to make an interesting trunk shape and scrub off some of the color with a wet sponge. The dark trees can also be painted after the paper is dry.

Mix Winsor green, New Gamboge and burnt sienna into a dark olive green. Keep variety in the color as you paint by adding red or sometimes yellow. Paint pine branches holding the snow. The best time to paint is when the paper begins to lose its glisten.

Some calligraphy of branches and needles and some shadows in the light snow complete the painting.

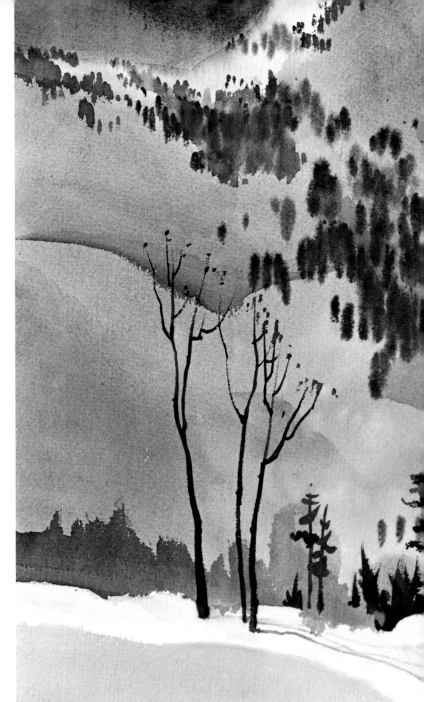

Colorado Winter

Distant Trees as Big Shapes

This picture was painted wet into wet. The point of inspiration was the great form of the mountain and the clumps of distant trees generally grouped in oblique shapes. A No. 8 round brush was loaded with pigment. These trees were painted with the brush held underhand, almost parallel with the paper. The trees were stamped on by pressing and lifting the brush. Because the paper was damp, the shapes diffused just enough to create the desired soft edges.

The sunlit snow at the top was tinted because a white shape so close to the picture border tends to pull the eye out of the composition. The white snow and contrasting red barn read easily as the center of interest. This is reinforced by the grouping of the clumps of trees leading down from the upper left and in from the lower right.

The warm shapes of the deciduous trees in the foreground were

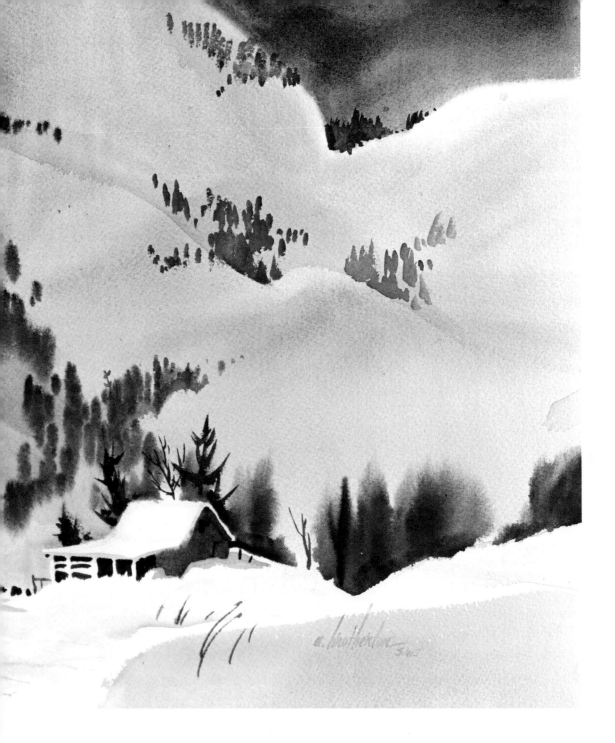

painted after the paper was dry, as were the dark pines just back of the barn. To paint them, a one-inch square brush full of liquid pigment was used. By putting the corner edge of the brush where the thick part of the branch leaves the trunk, and brushing up and lifting as you come up, the top edge is made lighter. Vary these shapes by twisting and turning the brush. The dramatic sky of dark, dark blue was used to make the gray read as white snow in shadow.

Successful wet in wet effects depend largely on your experience with the medium. Practice will give you the know-how. Remember when painting wet into wet, the pigment dries lighter and tends to soak into the wet paper. Shapes do not hold, or else they make blooms. Colors sometimes bleed and separate as with Winsor green and alizarin crimson. Only experience and lots of practice will put you in control.

Adobe Casa

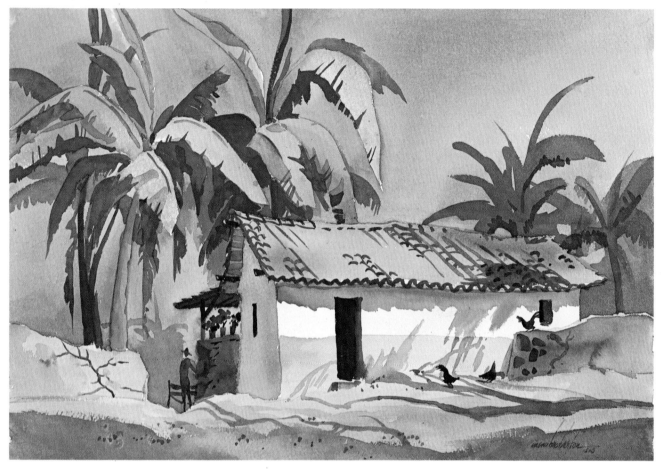

Banana Trees

Painting without pencil drawing will produce more relaxed design patterns. Banana trees and palms lend themselves to interesting shapes, but even good shapes can be monotonous if they are too much alike.

This picture was painted on dry stretched paper. The shadow side of the house shows the warm reflected light at the far edge and the darkest area at the plane change as the house turns the near corner. Also there is warm light reflected under the eaves of the roof. Note how the red tile roof is handled with but a few dark strokes defining the tile's shape and texture.

Only the yellow-green shapes of the leaves are painted first, watching for variety in size, direction, color, value and shape. When they are dry, the gray sky and foreground can be painted. Paint around the yellow-green shapes in order to keep from losing their transparency. After the sky is dry, the dark green shapes can be carefully designed about the yellow-green leaves. Note the great variety of green in these areas, some very warm, some dark, and all different in shape and size.

I selected this picture in order to demonstrate the differences in the colors of cast shadows. On the white part of the house the shadows are a warm gray. On the green area they appear as a deeper green value. Cast shadows do not have to be blue or black. Transparency is the important quality of shadows. Sometimes shadows read well if painted with the complement of whatever color is in the area, or the shadow can be painted a deeper gray.

Summer Cabin

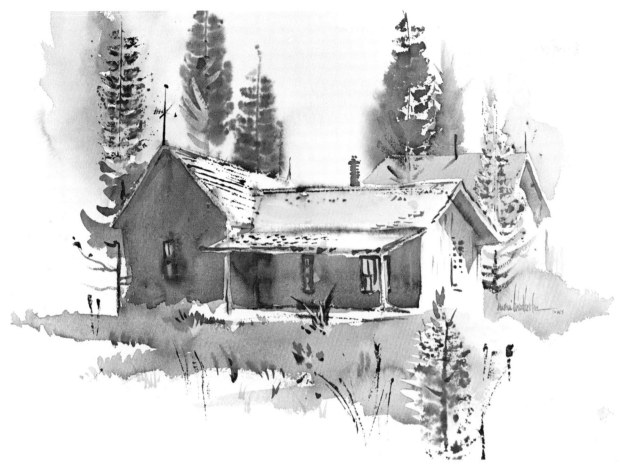

Stamping in Tree Shapes

Loose and easy does it! Have some fun! Try this exercise. Working on stretched dry watercolor paper, brush water over the surface. Squeeze fresh pigment on the palette. Decide whether you want a cool picture or a warm one, and choose a color scheme and a dominant color.

Dip the edge of a plastic credit card in a mixture of thick indigo and brown madder, and block in the house swiftly and loosely with the paint on the edge of the credit card. If the painted lines bleed a bit, so much the better. Draw the house in perspective. Try to create unequal spaces so the design has interesting variety. Choose a house with simple shapes.

Stamp in the trees while the paper is still wet. Place a small drop of household detergent on the palette. (The brand I use is *Joy.*) With a small amount of detergent on a brush, wet the back of a fern leaf and then paint your selected pigment over it. Place it on the watercolor paper where you want a tree. Put a piece of non-absorbent paper over the leaf and lightly press it to the paper with your fingers or with the palm of your hand. Lift the paper and the leaf and you have a tree!

At the roof line or at any place where you want a clean, distinct edge, mask the area with a piece of non-absorbent paper. A page from

a magazine or a piece of typing paper will work well. The leaf will print on the watercolor paper above, and on the magazine page at the point of contact. When the mask is lifted, the tree will stop at the roof of the house or at the grass, or wherever you want.

Stamp one tree over another. Vary trees in color, and space them with variety. Some can be taller than others. Some may be pressed on with a positive shape. On others you can paint around the leaves of the fern to make negative shapes.

While the trees are drying, paint the warm light reflecting underneath the roof of the porch on the house. Light bounce or reflected light is warm. Artistic license allows us to exaggerate such areas if spots of color will help the picture. This picture is not supposed to be realistic. It is an effect.

Use the edge of the credit card to stamp in texture and windows, or you can use the beveled edge of mat board cut in any desired size or shape. Use lost and found edges and work for a variety in textures. Don't do the same thing over and over. Be inventive . . . many things are available to create interesting stencils that can be used either for lifting light shapes in a dark area after it is dry, or stamping positive or negative shapes anywhere.

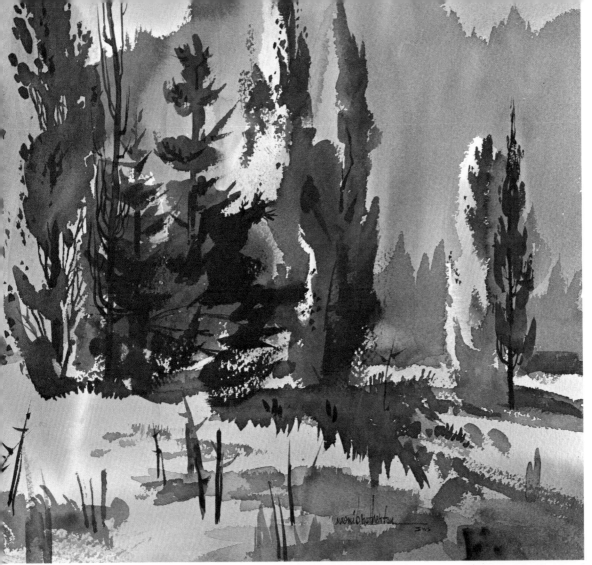

Sun and Shadow

Positive and Negative Shapes

This painting began with a warm underpainting, wet into wet. The light greens of the near tree shapes were painted next, just before the underpainting was completely dry. This color represents the light side of the trees, but the overpainting makes the trees different from the sky.

The distant dark shape was carefully planned to have variety and interest across the top. This wash was painted around the tree shapes. Care was used not to let the tree tops parallel the distant shape.

After everything was dry, the dark shapes of the trees were added, as well as the shadows on the ground. The light areas at the corners were reduced to keep the strongest contrasts near the center of interest. Calligraphy was painted in the dark sides of the trees while striving for contrast of darks and lights near the center.

4 Mountains

*P*eople who have lived their lives within sight of majestic mountains develop a sort of worship for their sublime beauty that always dominates the mood of the area. For those whose acquaintance with the high places of the earth is limited to a vacation or to some brief encounter, painting mountains can be an intimidating experience. Mountain ranges come in many shapes, and they can be painted in many different ways.

A series of backlit ranges lend themselves to a painting of graded washes on dry paper. It is important that at no place can the mountain in front be painted in an area not covered by the mountain just behind it. If it extends above or beyond the mountain behind, it will appear transparent and you will feel that you are looking through it. In other words, each mountain peak as it comes forward should be contained within the shape behind it. These washes are accomplished by liquid pigment in a brush, beginning darker and losing color quickly to almost clear water which is painted to the horizon each time. Each range must dry before the next one is painted.

Mountains may occupy the big areas in a picture so their shapes are of paramount importance. Pre-planning should keep them from being repetitious and monotonous in shape, size or spacing. The edges of peaks and ranges do not parallel one another making triangles and concave lines. The peaks should not appear static. Each shape should be oblique, with a thrust that is going somewhere. They appear darker and warmer as the layers come forward. Painting without drawing gives freedom for change without the need to erase later. Sometimes pencil marks erase easily after the painting is finished. Sometimes the graphite is stubborn. A 2B or HB pencil will usually erase. Some soft pencil lines are almost like grease to try to erase.

Mountains as Interesting Shapes

The process of painting this picture is essentially the same as that in *Big Bend* (pg. 78). The most distant mountain was a blue graded wash quickly diminishing in color, but carried all the way to the low horizon. It included the shape coming across the valley at the top where the front mountain would later be painted. The back mountain has to nearly contain the shape of the front mountain.

The stream is a foreground repeat of the values and colors found in the sky. The water is flat across the back with the banks drawn to suggest the perspective so the stream will appear to flow across the surface of the ground.

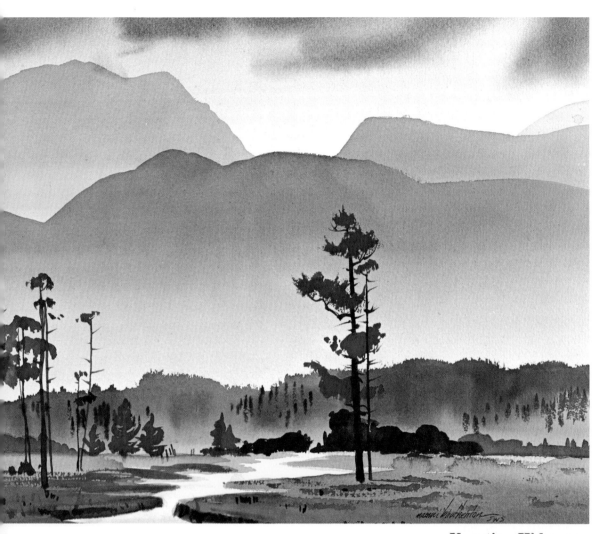

Vacation Hideaway

The mountains are established as good shapes with interesting, inter-locking edges. But they are extremely simple so that the foreground trees against them form the interest area and set a scale helping to create a feeling of depth in the valley. Note the variations in the placement, shapes, values and colors in the tall trees, as well as in the distant trees. Their vertical shapes serve as a needed counterfoil of the dominant horizontal mountains.

Picture captions often inform the viewer of the colors used in a painting as if that were a secret. More important than colors are shapes and values. Almost any colors will be appealing if the shapes are good and have variety, and if the values are correct. In this painting make note of how warm the colors are in the foreground, and how cool they are in the distance, with careful gradation between the distance and the foreground.

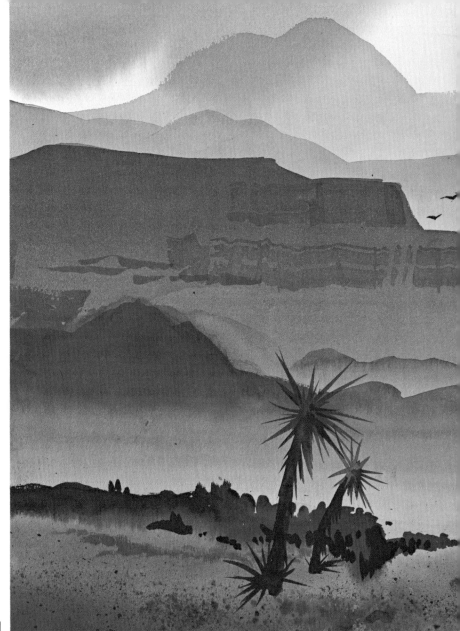

Big Bend

Mountains as Graded Washes

This picture was inspired by the Texas mountain ranges in Big Bend
National Park. The soft clouds were dropped in wet into wet painting to
the horizon line. It was a part of the stretching process. The paper was
wet back and front, the sky painted, and then the paper was stretched on a
mahogany support board and allowed to dry.

The mountain ranges are different shades of indigo and brown
madder, beginning blue and becoming warmer as they move forward. A
small value sketch helped me plan the shapes. They depict the exposed
horizontal strata that flatten out as they typically do in Big Bend Country.

Note the shapes of the mountain peaks and the interlocking edges of
the mountain ranges. They contain no concave lines, no exact repetition,
and hence no monotony. They are basically oblique shapes so they are not
static. The gradation of the values move from cool to warm, with each
range becoming warmer as it appears closer to the observer. The nearest,
lowest range of rolling hills was warmed with New Gamboge. The
foreground harmonizes in color with the distance, but was painted as a

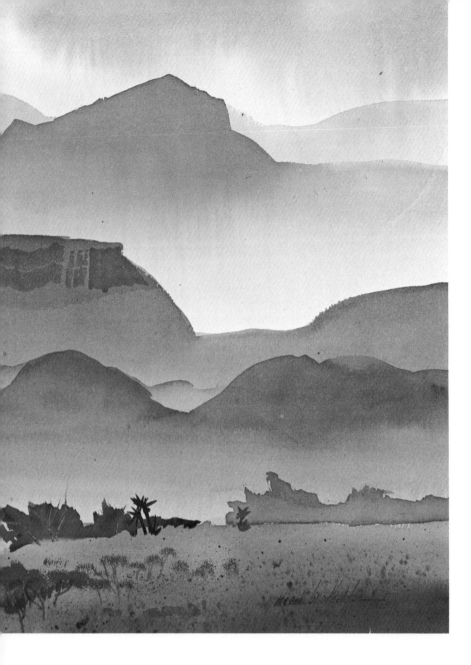

graded wash in the opposite direction, warmer in the foreground.

The graded washes were painted on dry paper with a juicy liquid pigment of the correct value. I painted without sketching on the paper.

The first layer of blue mountains included the shape and thrust of the second layer on the right as it comes higher than the back range because the front mountain must be contained within the shape of the back mountain or it may appear transparent. Each wash diminished color quickly and was painted all the way to the horizon. And each wash was dry before the next group of mountains was painted.

This picture represents gradation in value, size and color. The yucca creates plant life in the center of interest, supplying a vertical relief that lends texture as well as scale to the foreground.

The birds add a touch of life and movement, and are placed so they do not lead the eye out of the picture, but through the picture from the light to the dark shapes in the foreground.

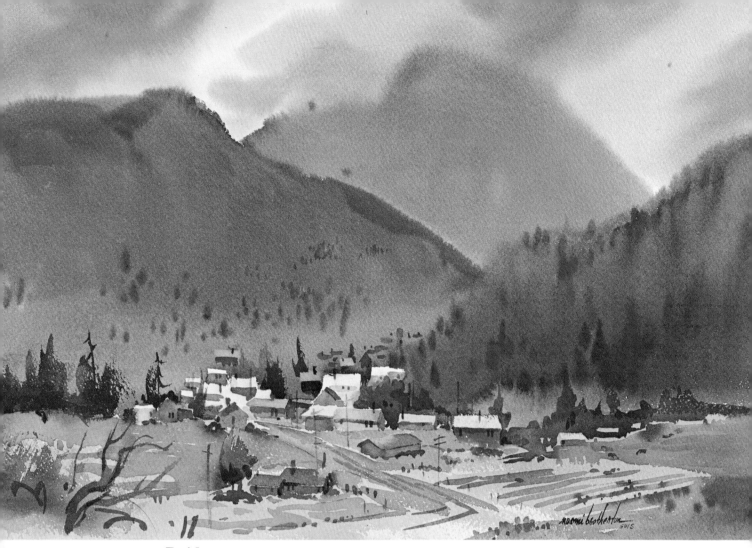

Ruidoso

Our eyes take in too much, especially when we are outside where there is much to see. Painting a picture always calls for much simplification. You will understand how to control what you see if you keep things organized in your planning and thinking. Try to maintain specific areas of your composition clearly—foreground, middleground and background.

This view is of the little village of Ruidoso, nestled against the mountains of New Mexico. After the sky was painted, the back mountain was shaped while the paper was moist so there would be diffusion to help indicate a cloudy day. Variation in shape, color, size and texture of the mountains was a prime consideration.

Light areas were saved for the houses, and some spaces were blotted out with tissue while the paint was still wet. Later, after the paper was dry, shapes were repainted to describe the edges and colors of the buildings. The small trees were the darks. These are linked together with the small roofs to make a variety of shapes. The road in the foreground and the light area in front lead the eye into the picture. The corners were painted with a darker value to retain interest within the picture borders.

Mountains — Wet into Wet

Mountains are a joy to paint wet into wet, especially those sections close enough to show heavy foliage. The paper can be wet on both sides, or it can be pre-stretched and wet at the top at the time of painting.

High mountains read well against a soft sky. Drop in the colors while the paper is wet enough to give considerable diffusion. The sky should be darker at the top and become lighter where the mountain makes its silhouette. It is using dark against light for drama and interest.

Do not sketch in the top of the mountain before painting. It is difficult to follow a sketched line regardless of the interaction that takes place between color and water. The nature of watercolor sometimes allows beautiful things to happen on paper, and the artist is wise to accept such contributions. However, it is advisable to loosely sketch in the shape of any building in the foreground extending up into the mountains. Before painting the top of the mountain, wait until the

edge will hold but still keep some softness against the sky.

From your chosen palette mix a good, strong, gray color of a rather dark value for the mountain. You will need a lot of this mixture. As you paint, warm the color with red or cool it with blue. Vary each stroke. Carry ample pigment in the brush and not too much water. Shape the top of the mountain with an eye to variety of angles and direction. The top protrusions should not come at regular intervals. They should conform to good design with two coming close together and a third far away. Measure the negative spaces and change spatial relationships as needed. Paint around the building.

Study what you have put on paper, squint to shut out the light, and study your shapes, values, hues, light and dark contrast. Don't stir around with the brush at this stage or you will overwork it and get a muddy quality. Probably the watercolor should not be touched anyway. If you put more water in your brush than is on the paper, you will likely create a bloom.

Picture Evaluation

As always when painting wet into wet, it is a bit of a gamble. These two pictures furnish a good comparison.

Both skies seem satisfactory, darker at the top and lighter at the mountain edge. In *Valley Home* the mountain top is a better design silhouette, and the sky area is a more interesting shape. However, I failed to leave space for any lights in the trees. *Hacienda* has lights for interesting tree shapes and shadows. Both pictures have lights in the front that direct the eye in. In the plowed field, the vanishing point of the rows is suggested, but not overstated to keep it from competing with the building as the center of interest. In *Hacienda* the foreground is simple, but adds sufficient interest in variety of color, value and texture to properly place the structure in the middle distance.

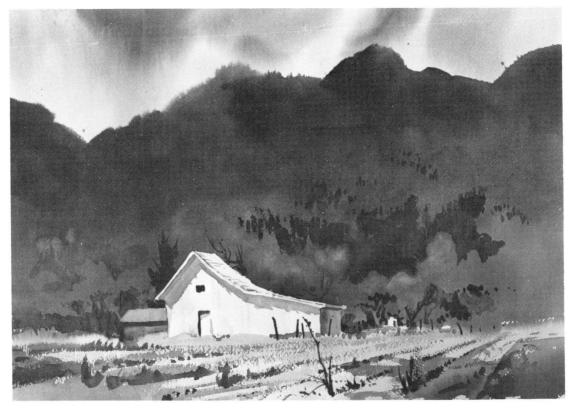

Valley Home

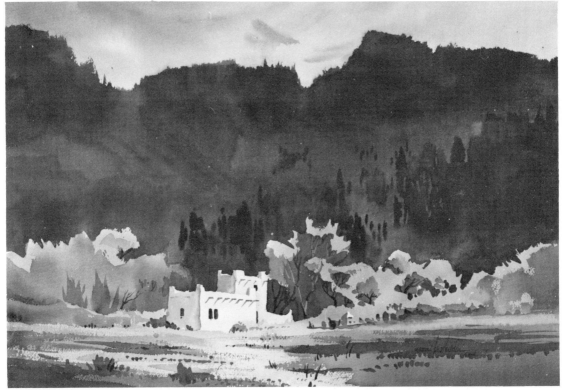

Hacienda

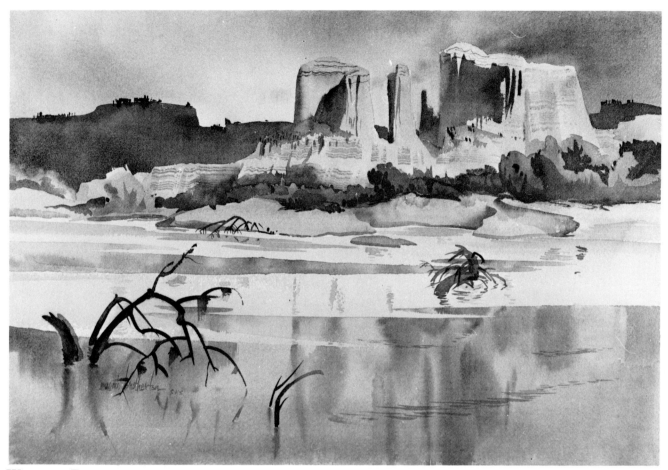

Western Buttes

Balance

A butte is an isolated hill or small mountain with steep and precipitous sides, usually having a smaller summit area than a mesa. In my picture the color is no more brilliant than the actual color as seen in New Mexico or Arizona. The light sides represent the areas in which the sun bleaches out the color to a tint. The stronger color appears in the shadow sides. It is fascinating the way these shapes interlock with the sky, no two measures are alike either horizontally or vertically.

The water was painted horizontally in conflict with the vertical buttes. The reflections were dropped in while the painted area was wet, creating additional verticals. The perspective is suggested by the way the strips of reflections on the water become smaller as they recede.

The bush on the left helps to balance the buttes. Balance is the equilibrium of opposing forces. There are two types of balance. Formal or symmetrical balance occurs when the two sides are alike or very similar. Then there is informal or asymmetrical balance. Informal balance is achieved as a man balances a small boy on a seesaw. The boy moves far out on the end of the seesaw and his small weight offsets the greater weight of the man. Informal balance is less stately, less peaceful, less obvious, and more interesting.

84

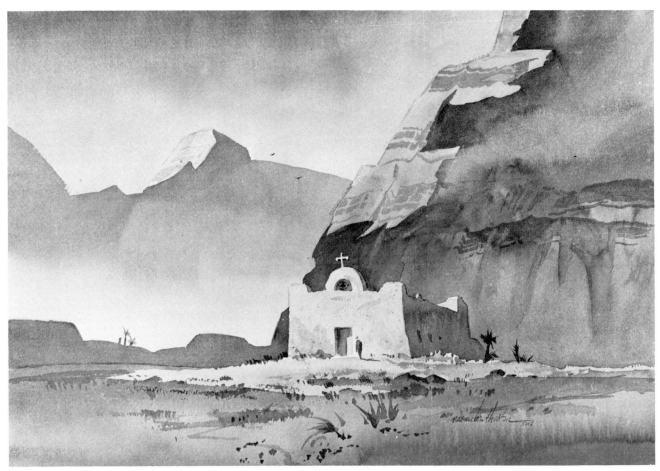

Glorietta Mission

Detail and Texture in Sunlight

At times the sun may bleach out much of the color and detail as in the previous picture, *Western Buttes*. At other times the sun reveals texture and detail as in this instance. There are raised stones, rocks and textures, which, in the sun, cast a shadow and show as detail in the lighted areas of the mountains. It is best not to paint texture and detail in both sun and shadow areas. If the sun bleaches the color, put the detail in the shadow. If the sun reveals the detail, paint the shadows as dark areas almost devoid of detail.

It is late afternoon and the low rays of the sun shining through the denser portions of the atmosphere bring warm lights to the mountain top, building, and part of the foreground, revealing detail in these lights. The shadow sides are cool and rather opaque. A mountain as close as the nearest one would show some detail, but it is understated so as not to compete with the light areas. There is little light bounce because the sun is too low.

This painting has a cool cast due to the blue distant mountains and to a small degree because of the green door. That clear Winsor green is a surprise element, and it helps to overcome the warm dominance of the foreground. A red door would help establish a warmer dominance.

The three small trees in the distance add scale and interest to the painting and make the distant haze appear more luminous. The mountains were painted as graded washes on dry paper.

5 Skies, Mountains, Foregrounds

Skies

Nature generally imparts to us a feeling of stability, strength and an essence of eternity. Mountains stand forever. Rivers cut new paths, but with a deliberation that is hardly noted in a lifetime. The rocks, the hills, the valleys exist over time with little change. The seasons follow one another in rhythmic order. Only the skies change drastically from day to day, from hour to hour, sometimes from minute to minute.

Transparent watercolor is the almost perfect medium for painting the vicissitudes of atmosphere. Liquid pigment dropped on wet paper flows and blends into brilliant or soft colors that remarkably resemble our remembrance of skies.

Try this exercise. Wet on both sides a sheet of good quality 140 lb. cold pressed paper. To make skies spontaneous, wait for the right moment when the paper loses its glisten and is ready to receive the paint. With a large brush, make a clear, precise statement with ample pigment on the moist paper. Use as few strokes as possible in as little time as possible, and then leave it alone. The temptation is to rush into the wet paper too soon. Then, when the paint spreads too much, it is hard not to keep trying to "fix" it. Soon it is overworked. Mud is the result.

Putting in the first color amounts to the same thing as wetting the paper again. You may need a little drying time before you paint the clouds. When the paper is ready, shape the clouds, using a strong pigment mixture and little water, but not opaque, thick paint. With each stroke, think—good shape, interesting relationships, intriguing negative areas. I like to make larger clouds at the top, letting them become smaller as they go back in perspective. Nearer clouds are warmer, and receding clouds often seem more flat across the bottom. There is sometimes a warm light reflection at the bottom of clouds. In the distance, nearer the horizon, the small clouds run together, and you see the effect of the denser atmosphere. The clear blue sky can be darker or lighter than the gray clouds, depending on where the sun is located.

If your painted sky is appealing, clip it to a masonite board or staple it to a mounting board to dry. However, if your sky painting is not all you expected it to be, take the board and paper to the sink and wash it off with a sponge immediately. If you do not wait too long, almost all of the color will wash off, and you can begin again.

A number of sky paintings have already been included in this book, and some information has been given about painting them. They are: *Fisherman's Shack, September Morning, Retreat, Summer Solstice, Lone Sentry, Autumn Signals* and *Wintering Willows.*

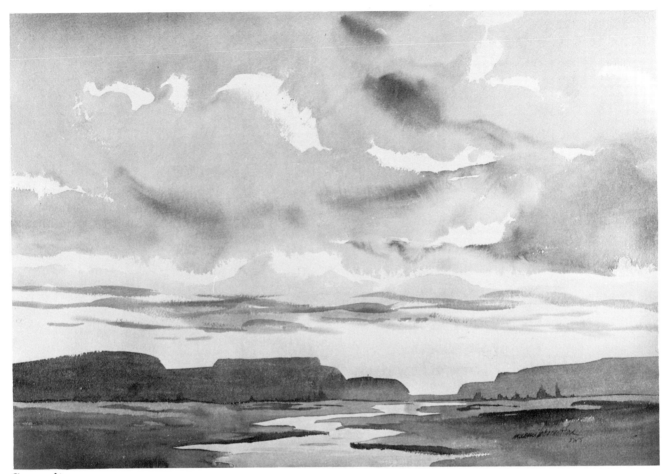

Serenity

Skies, Center of Interest

Clouds and skies sometimes are dramatic enough to occupy almost the entire picture area. These clouds were painted on dry 140 lb. Arches cold pressed paper. It was not stretched.

The whites are the important shapes, so making the whites interesting becomes the problem and the challenge. Clouds change and move so rapidly that it is impossible to capture a shape if you try to look and paint at same time. First, I studied the small cumulus clouds that seemed to checkerboard the sky. I wanted to capture the way they seemed to be racing each other. After studying them and deciding on my plan of action, I turned from the clouds and without looking again to the clouds for shapes, I focused my attention on the relationship of shapes as I painted. No preliminary sketching was done. I began painting negative spaces with blue, being careful to leave the white cloud shapes.

Looking up, the tops of the white clouds seem hard-edged and the bottoms soft and flat. When the blue was dry, I added the warm gray, creating some soft edges. Perspective is a consideration with clouds. The closer ones overhead, occupying more than the upper half of the painting, are made larger and show more detail. The next row is only a narrow strip, with each row diminishing toward the horizon. In reality it does not always happen this way, but when creating a picture it helps to use the cloud size to clearly establish the feeling of distance.

A simple suggestion of a landscape will finish the painting. In this one, the lazy river repeats the blue of the sky and completes the panorama of the clouds.

87

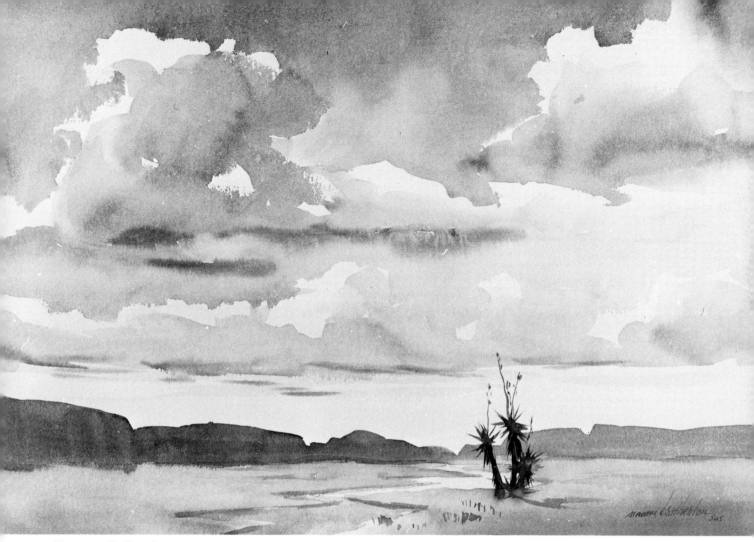

Desert Solitude

Skies and Simple Foregrounds

These clouds are a variation of the ones in the previous picture. The yellow orange atmospheric color was painted in over the clouds, beginning at the horizon line and losing the color in a graded wash. The paper, clipped to a board, was tilted away from me so I could control the graded wash, carrying clear water over the sky after the color diminished. If the yellow turns the blue sky slightly green, it is good because that is typical of what the atmosphere does. The yellow-orange will also warm the whites and gray the cooler shadows.

Before you paint the grays, decide whether the blue sky is darker or lighter than the value of the shadow sides of the clouds. Sometimes they seem darker, sometimes lighter. If the values of the grays are too dark, the clouds may look like plaster of Paris instead of vapor.

You will want to try many skies. The other side of the paper is usable if the first one does not turn out as you wish.

After the sky is dry, paint in an imaginative foreground. Remember, the sky is the subject matter; it is the center of interest. Don't put in a foreground that will compete, but one that will complement. Hold to your color scheme and experiment with different subjects. A small yucca plant or a windmill can reach up into the sky and interlock land and sky, but the statement should be simple.

Large Foregrounds

Big foregrounds sometimes pose a problem, but to avoid mastering the difficulties is to rob yourself of one of the great pleasures of a painting. With dominant foregrounds you can capture the hot browns and warm golds of the deserts, the sun bleached greens of the sand and cactus, deep snow drifts, long blue shadows winding their way down hillsides, and the magnificance of green meadows filled with grass or spring flowers.

Gradation in color is important in painting all foregrounds. The area in front is definitely warmer, moving gradually or rapidly, depending on space, from cool to warm. The warm color in front, whatever it is, gives the feeling that the foreground comes toward the viewer. Gradation in size, with the larger shapes toward the viewer, gives perspective and creates a feeling of depth even on a flat surface. Gradation in values also creates perspective. Here there is no hard and fast rule. The lighter values may be in the back of the foreground area. The dark may be in the back, moving to the light in front.

Variations of values and color change are the telling elements in a large foreground, not detail. Good shapes and gradation in value, color and size make a foreground interesting, and lead the eye from one beauty spot to another, bringing the viewer to the center of interest.

Only a small bit of detail is essential to make the whole foreground understandable. A lot of detail may make the area too busy and keep the eye from finding the center of interest.

It is best to keep foregrounds simple. Beginners often paint "things" such as bushes, rocks or tall grass in the corners of the painting and then wonder what to do in the heart of the picture. Value change and color change kept simple in the corners are enough. The use of calligraphy to suggest elements is usually sufficient for viewer identification. Only the immediate area of the center of interest requires more explicit representation.

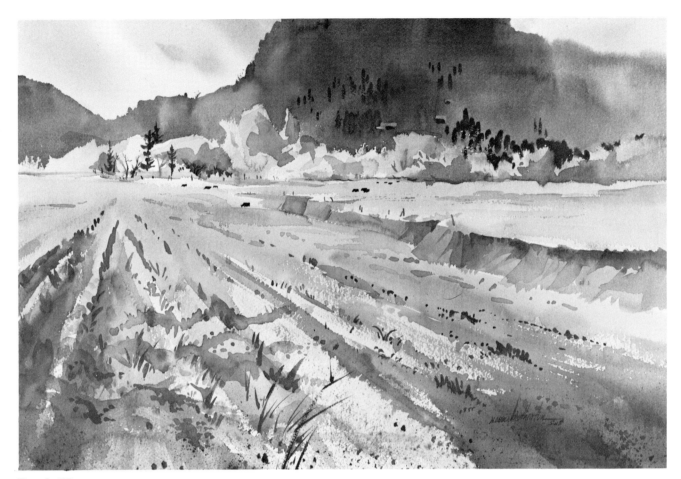

Back Home

Perspective

This picture has a high horizon and a large foreground, making a good division of space. The soft sky and mountain silhouette with areas left for light trees are all things we have already discussed in this section. Take care that the mountain does not *bump* too much at the top. Make it go completely out of the picture with a big shape, leaving the sky space a small but good shape, or make sure it fits within the picture with sufficient sky to explain its location.

The terms, *warm colors* and *cool colors*, are relative. Whether a color is warm or cool depends entirely upon the surrounding hues. By themselves, the colors in the trees and grass are essentially warm, but in comparison with the richer, warmer reds in the front of the plowed rows, the foreground moves easily from warm to cool. The furrows, going to a vanishing point on the horizon, lead the eye into the picture.

The foreground is in itself simple, the sun washing out the color and detail in the back. There is value change from light to dark, color change from cool to warm, size change from small to larger furrows as the foreground comes closer to the viewer.

The corners are simple, but have a darker value to hold attention within the picture. The only detail consists of a few drops of spatter in the light area in front and around the grass.

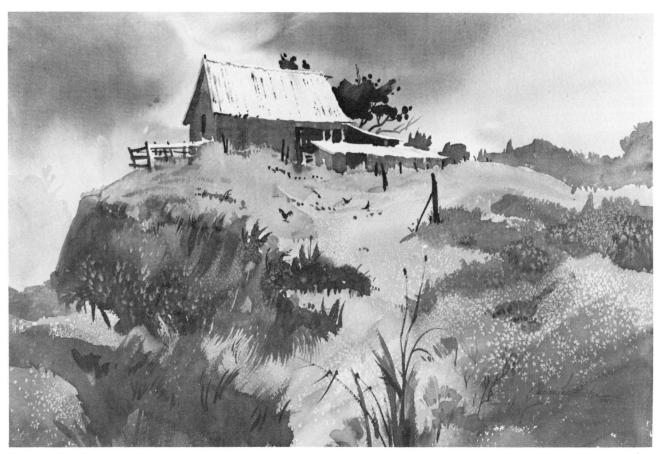

Mountain Crest

Movement

The horizon in this painting is not a high horizon—it is actually quite low. The artist is looking uphill. The hill is the large mass and is a shape within itself, interlocking with other elements along the edges. It also makes an interesting space division and a big foreground.

The color scheme is a simple complement, red and green with a warm dominance. Nature's green in this picture is more warm than cool. A bit of salt sprinkled in just as the glisten was leaving the paper created the small flowers effect.

The picture has dark and light contrast in the foreground; shapes, obliquely related with positive and negative interlocking edges; textures and symbols for grass rather than detailed representation.

The sky was painted wet into wet, and the hill was created with light flowing colors moving from cool to warmer hues in front. After everything was dry, the barn, fence and darker values were painted. The light coming in at the top pulls the eye into the center of interest at the barn, where it follows the white of the roof and the light path through the foreground. The bits of calligraphy and grass at the bottom give a feeling that there is more outside the picture.

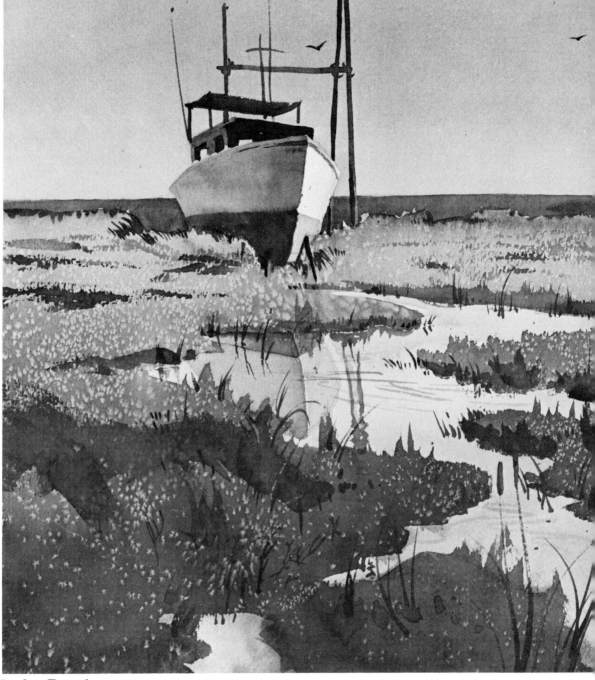

In for Repair

Foreground, Value Changes and Color Changes

An interesting foreground usually has something happening in it. Here the inland water brings the cool of the sky and ocean into the foreground with a variety of shapes with color and texture variations. The banks of the water are painted to suggest some perspective, helping to make the water lie flat. The dark blue ocean and plain sky stabilize and serve as a contrasting foil against the busy foreground.

The foreground was painted as an underpainting of yellow, becoming orange and then a deep red as it moved forward. I painted around the water. When this was dry, I painted the green over the cool to warm underpainting. As the glisten was leaving the moist paper, salt was sprinkled into the wet paint, creating the flower texture. This painting represents the use of a considerable amount of salt. If too much is used or it is put in too soon, the backruns will be too great and will not result in

the desired effect. If the green glaze is mixed with Antwerp blue, the action will be better and the green will be pushed out of the way to reveal the underpainting of red and yellow flowers of many variations. In putting in the salt, I opened only one or two of the holes in the shaker and carefully spaced the sprinkles in interesting patterns. Because you cannot see the salt action at first, you are tempted to put in some more. Don't. Wait. When the action starts, it is easy to see. And it is easy to get too much. Because of the tilt of the board, the glaze was dryer in the distance when the salt was sprinkled on, so the flowers are smaller.

The reflection of the boat in the still water is a reverse repeat, and the color and value are muted by the local color of the water. The value contrast is reduced and there are a few ripples on the surface to establish the fact that there is a water surface.

6 Buildings

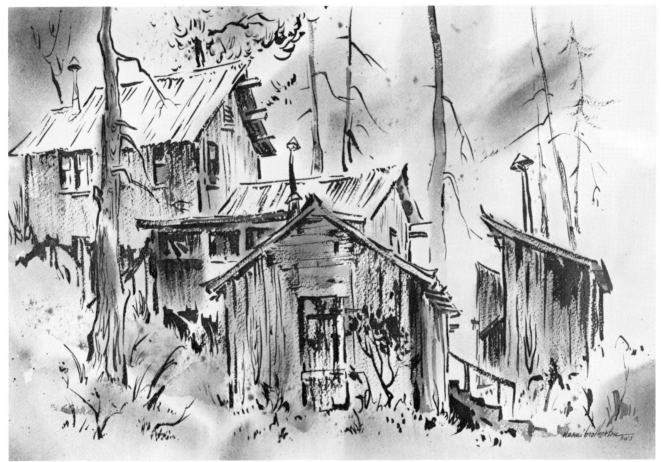

Mountain Lodge

Ink and Brush Drawing

This picture began as an ink and brush drawing on 140 lb. Arches rough
watercolor paper. I use Pelikan black or Black Magic Ink. The brush is an
expressive and creative instrument. Some lines are wide and strong, some
thin, some wavy, and some edges are lost. A few of the brush lines rep-
resenting limbs terminate in an expression of foliage. Some edges on the
buildings trail off into textures, and parallel lines go rapidly to vanishing
points so as not to appear static. The ink drawing was completed and
allowed to dry completely. The best idea is to dry with heat or wait a full
day for the ink to dry so it will not run when it is wet.

With a masonite board as a support, wet the back and front of the
drawing paper with a saturated sponge and allow time for the paper to
become limp. Flow in color and let it diffuse; it need not be confined
within the edges of the ink lines. This is often referred to as *open color*. A
few details may be painted in place as needed. This was done under the
eaves at the top left hand corner.

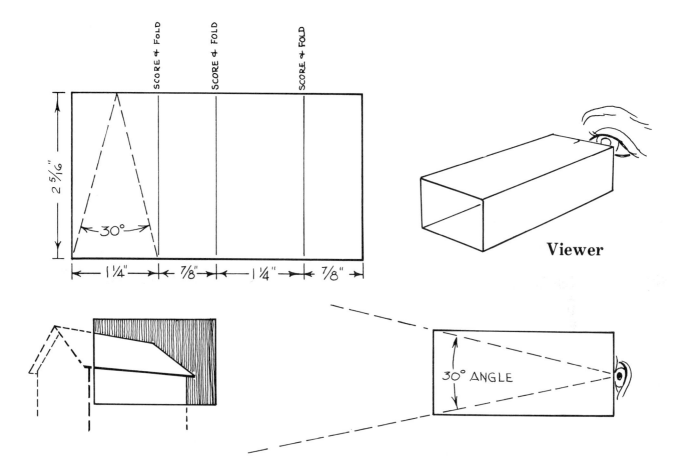

Viewer

*L*et us turn to the important task of capturing the perspective of buildings such as the ones in *Mountain Lodge.*

Our eyes can see with understanding only about a thirty degree range. When on location, it is easy to see too much, not only too many things, but also too wide a range. A viewfinder, which confines the vision to a thirty degree angle, will help you select a view. The viewfinder diagramed here is easy to construct, easy to use, and easy to carry. It should be made with the same proportions as the paper on which you plan to paint. The proportions given here are for a half sheet of watercolor paper. Use lightweight poster board which folds easily. The completed viewer requires only one piece of tape.

The viewer is actually only a test to see if you are far enough from your subject to take in all you plan. If you cannot see the entire structure from your station point, the place where you are standing, you will need either to move further back or to draw only as much as you see through the viewer.

Holding the viewer straight, you can judge the angle of the edges by their relationships to the verticals or horizontals of the viewfinder. Observing the shape of the negative space rather than the positive shape may also be of help.

When you have determined your subject matter existing as seen in the thirty degree angle of vision, you can observe and study the horizon line, the vanishing points and the size of the building you will use. then you can put away the viewer. It is not a composition finder. The ideal composition seldom, if ever, exists ready made in nature. Your composition is *your* creation.

Perspective

Although there is no line in nature, we express the corners or plane changes with a line. Line is the artist's way to show a change in direction of a plane or an edge.

If you placed a piece of glass in a vertical position at right angles to your line of vision and traced on it the lines of a building in front of you, the lines of the building would be in perspective. That is, the corner nearest you would be the tallest, and parallel lines would go to the same vanishing point on the horizon. If you are looking at two sides of the house, you will have two vanishing points on the same horizon line. We see buildings in perspective, not as lines running side by side with the same distance between them at all points. It is perspective that gives us a sense of distance in buildings, and many other things we see. It is this condition of things growing smaller in the distance that spells out perspective to us and lets us know that things are going back in space. The eye sees the sides of a house becoming smaller as they recede, and we are aware that there is distance involved.

Measuring Perspective

Hold a pencil at arm's length with the elbow straight. Keep it perpendicular to the plane of vision, and it can be used to measure any line proportion to any other line. The temptation is to slant the pencil in the direction of the edge you are measuring. Keep the pencil vertical and study the relation of the line you are drawing to it.

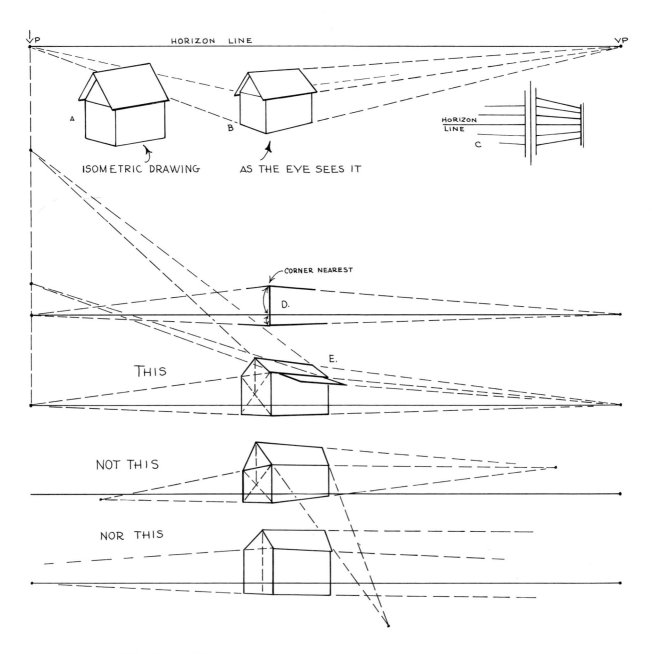

ISOMETRIC DRAWING AS THE EYE SEES IT

HORIZON LINE

CORNER NEAREST

THIS

NOT THIS

NOR THIS

Horizon Line

As we look into the unobstructed distance, the horizon is the line where the sky meets the earth. Many people do not realize that the horizon line is identical with the eye level. If a tall person and a child stand side by side and look into the same distance, they do not see the same horizon line. If you are at the top of a tall building, the horizon line changes because the eye level changed. If you sit on the ground, the horizon line changes again because your eye level changed. The horizon line and eye level are the same thing.

If an artist stands at one spot (his station point), looking at a house, he can hold a pencil or straight edge horizontally, six inches in front of his face, level with his eyes, and he can determine where the horizon line falls on the house. Knowing this will help when he begins drawing the vertical corner nearest to him, and he can determine the proportion of that line that is above or below the horizon line.

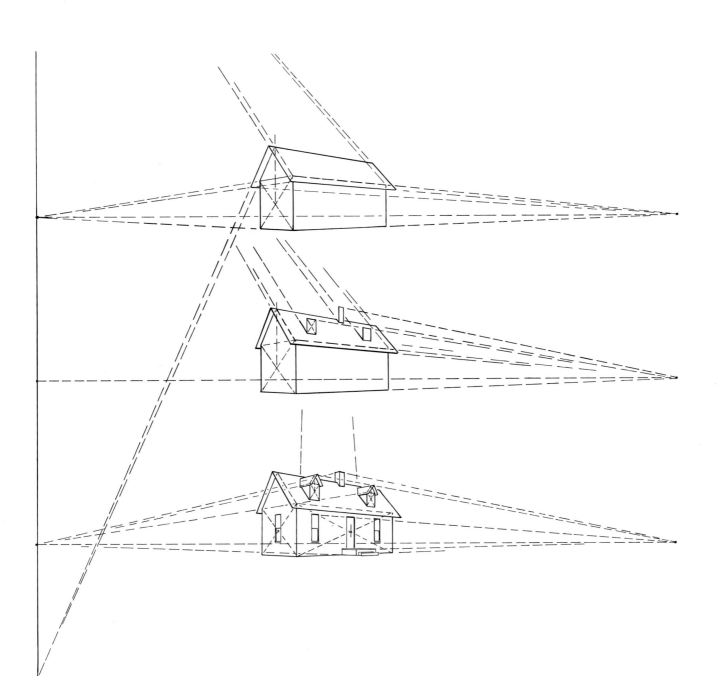

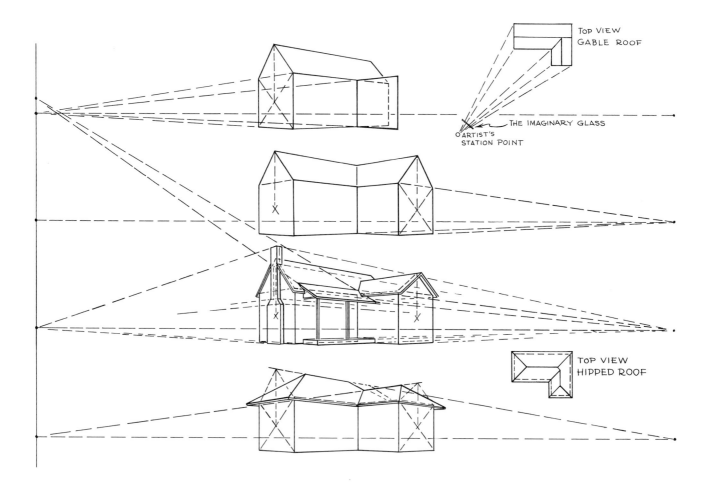

Vanishing Points

A vanishing point is the place where parallel lines meet, this occurs on the horizon line. Clapboards or bricks on a house are by construction parallel lines. If these are extended to the horizon they will locate a vanishing point.

If the artist can see any two sides of a house, he will be able to determine two vanishing points, one on each side of the house. If the vanishing points are far enough apart, even off the paper, the drawing of the house may not appear distorted. Once you have established the vanishing points, decide on the size of the structure and everything else falls into place. There is no guesswork involved. Dormer windows and even chimneys are easily drawn, all going to the same vanishing points. Porch floors are sometimes drawn as if they were dropping down like an apron. The stoop or porch is usually just a smaller rectangular area attached to the bigger form of the house, and therefore they share the same vanishing points. Study the accompanying diagrams. It is not as complicated or as difficult as it may sound.

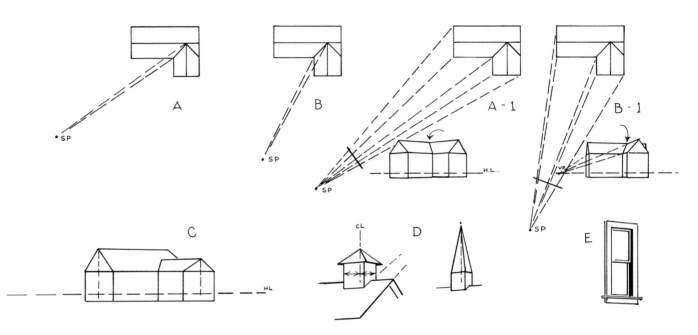

The valley of the roof is the point where the two slant roofs meet. The angle of the line is determined by the artist's station point. **A** and **A₁** and **B** and **B₁** demonstrate the differences between two station points.

C The further away from a building we are the more horizontal the lines appear.

D Draw the cube. Measure the point half way between and draw a vertical to the peak of the little roof.

E The variation in the thickness of the wall shows the detail in a double hung window.

Gables and Roofs

After establishing the basic form of the house it is easy to draw the roof. Locate the optical center by drawing diagonals at the end wall where the gable is located. These diagonals intersect at the center. The optical center may be slightly different than the measured center, because, in perspective, each measure gets smaller as the wall recedes. Therefore, the near part is wider than the part farther away. Draw a vertical from the optical center to a point as high as is needed above the structure and you will establish the pitch of the roof. A steep roof is higher and a shallow roof is lower. Study the diagrams for construction details.

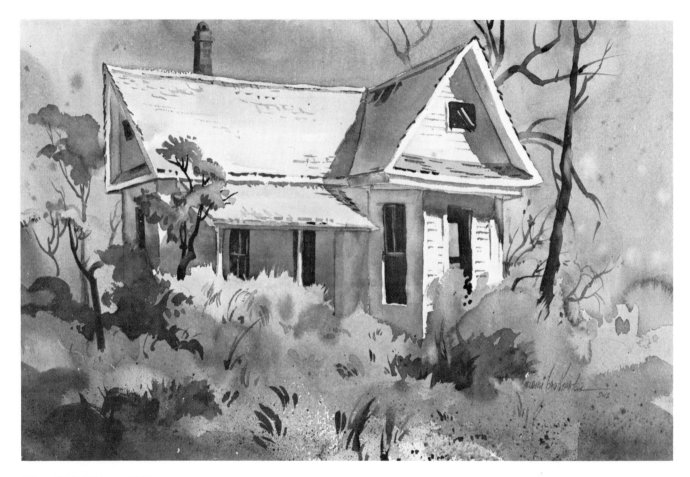

The Old Home Place

When the sun strikes the ground, a warm light bounces up under the eaves of a house and under porch roofs and into interior shadows. It may not appear actually as bright as I sometimes paint it, but I force the light for my own purposes. Such reflected light makes a warm glow throughout the picture.

A white house should look white even in shadow. In going from the white paper of a sunlit side to a shaded side on our value scale, use a gray value three to three-and-a-half value steps deeper to achieve the feeling of the shaded side. The cast shadow is still a darker gray with gradation, being cooler and darker at the edge. It is lighter as it receives light bounce under the protection of the eaves. The edge of the cast shadow becomes softer as it leaves the source. See value scale, page 102.

Window interiors and open doors are warm because the sky light cannot get in. Use a dark warm brown madder with just a little indigo to make it dark enough.

Distortion was purposely used in the left gable to animate the building and to add to the mood. On the house, the texture appears in the sunlight, but not in the shadow. In a painting it should not be seen equally in both places. A white face board was left on the eaves. A white house is a matter of value relationships. The close values make the darks more important. Do not let the tree cover the structural changes at the corner of the house. A bush or tree obscuring a corner of the structure can destroy or confuse the form.

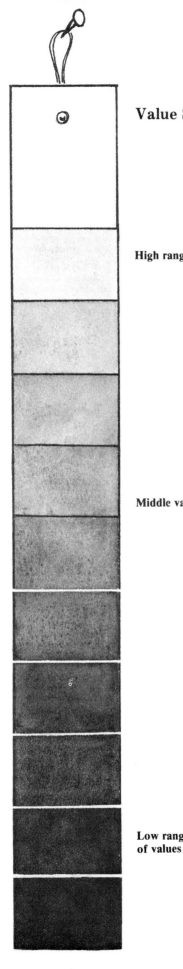

Value Scale

High range of values

Middle values

**Low range
of values**

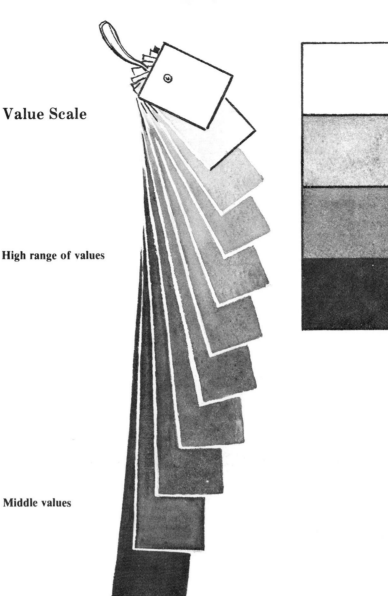

Values

Using zero to represent white, the absence of color, and ten for black, a mixture of all colors, we can set up a value scale of grays with five the middle. Some artists reverse the order of the numbers. However, I like to have white as zero because in watercolor we leave white paper for white and mix colors for dark values or for black.

In making value sketches in preparation for a painting, it is simpler to use only four or five values. As already noted, in turning a corner of a building from a sunlit side to shadow, the values will read better if they are three to three-and-a-half steps apart from light to shadow. Any color may be used, and any values, as long as they are approximately three steps apart.

A handy value scale may be made from separate strips of watercolor paper using ivory black to mix the values between zero and ten. By making each strip of paper progressively longer, you can see the entire value scale at a glance or select any portion for comparison with values in your painting. Place the value chip next to the color and squint to match values.

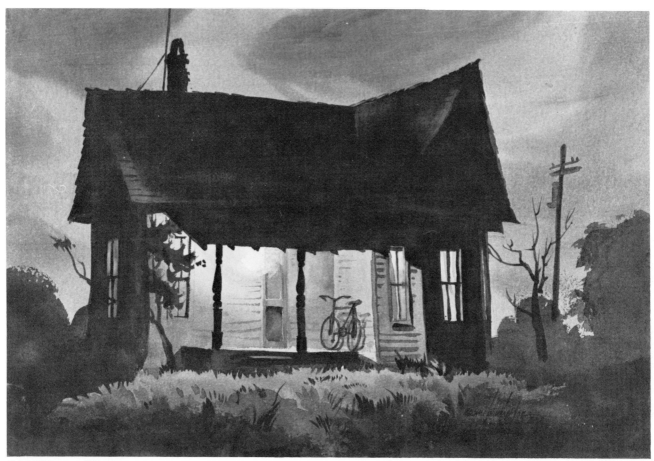

Old Home Place

Light at Night

This house is essentially the same as the white house in the preceding picture except it is a night scene. The source of light comes from the porch and from the interiors of the windows. From the source, the light becomes grayer as it goes outward, and it diminishes rapidly into the night. The house, the posts, trees, and front grasses form mysterious dark silhouettes against the light. If your sky is not dark enough, put another wash over it. However, remember that every time you add a wash, you lose some of the luminosity. A mid-tone sky can suggest early evening. Black pigment is not used because the beauty of the scene is dark transparency. Winsor green, alizarin crimson, and Winsor blue make deep mysterious blacks, as do indigo, alizarin crimson and sepia.

The horizon is low. In drawing, start with the corner nearest you, making sure the house will have a different measure from each edge and so will not rest in the center of the page. Find the two vanishing points and draw the box-like shape. Draw the diagonals on the left side, locate the center, draw a vertical for a high-pitched roof. There is some deliberate distortion in the house because of close vanishing points. It adds to the mood of the scene.

The bay window will have a different vanishing point from that of the basic house because it sits at an angle different to that of the house. This picture should be matted with medium gray and a wood tone frame so that there will be nothing to compete with the light source in the picture.

Reflected Light or Light Bounce

The warm, reflected light glows under the porch, on the far side of the false front and under the eaves. The dark trees shape the roof and the fence, which was done by painting the negative shape to leave the positive.

Here again, the color of cast shadows can be seen. The shadow is a deeper, richer green on the green roof; a combination of Winsor green and brown madder. It is a deeper grayed red on the red sign, and a darker red on the red flag. Add indigo to cool the shadow. The windows on the porch were made to appear as reflecting glass by protecting the area with paper and sponging out the window shape with a damp sponge. A light green glaze was put in after the windows were dry to give them a cool cast.

Sometimes a picture such as this has good compositional placement of the building in a value sketch. However, when you enlarge it, somehow it doesn't seem to fill the picture space as well as it did in the sketch. If this is a problem, you can easily grid your value sketch and also your sheet of watercolor paper and get exact duplication of space areas. Make center lines vertically and horizontally, and divide the four spaces again and you will have sixteen rectangles. Draw similar lines lightly on the large paper and draw your design, matching the rectangles. The sketch and the paper must be the same proportions.

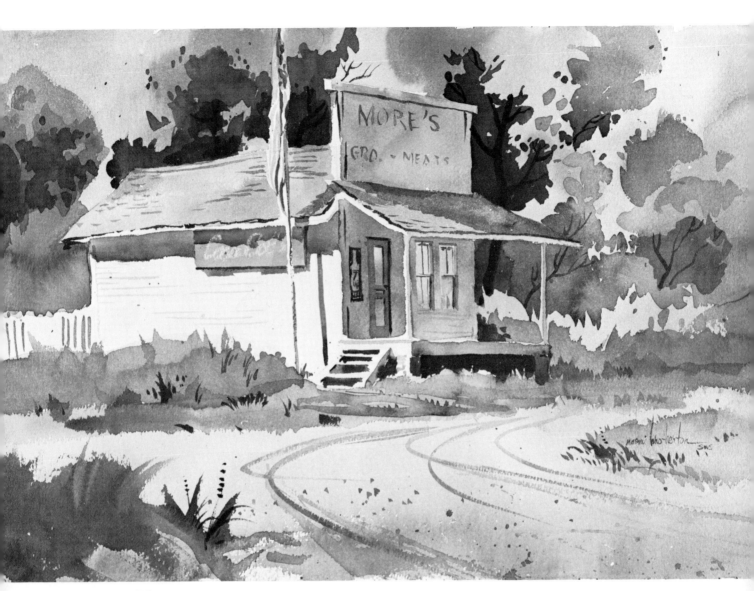

John's Place

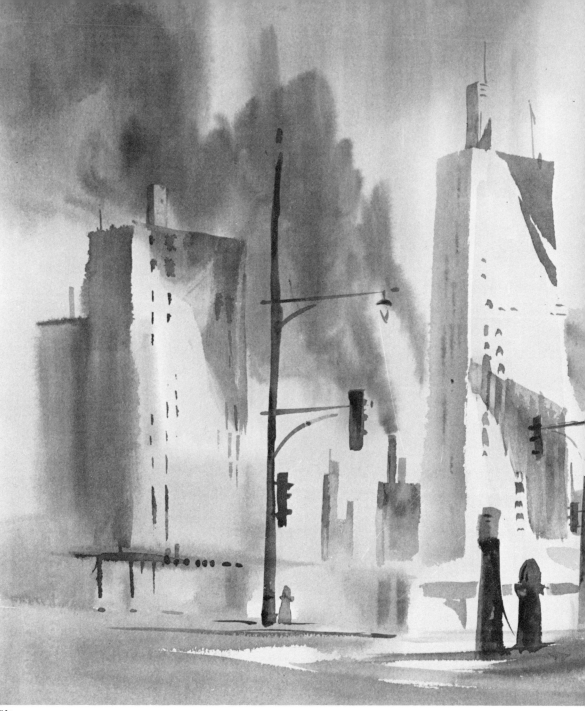

Cityscape

Vanishing Points in the Sky

Tall buildings are parallel lines meeting at vanishing points in the sky at a point usually at some distance beyond the page. If you are looking up at the buildings, they become noticeably smaller as they get higher.

If you were looking down from a helicopter, a tall building would have a vanishing point below the ground, and the building would appear larger at the top than at its base. Except when painting very tall buildings, artists usually stick to two-point perspective. Three-point perspective is essential, however, when you want to express great structural heights.

naomi brotherton sws

There are hard edges, soft edges and lost edges. A hard edge is made with a line of a color that definitely stops. Sometimes it is interlocking. A soft edge is made when the colors and values intermingle and flow together. A lost edge is one that is not always there: now you see it, now you don't. But mentally you are aware of it. If an edge has identity it is not lost. These indefinable, misty spaces that are not precisely described can offer variety, help establish a picture mood and be most appealing.

This picture is a series of lost and found edges. They open spaces for the eye to travel into the midst of the action.

Ski Camp

Lost and Found Edges

This vignette is a variation of *Summer Cabin* on page 73. The trees were made with imprinted fern leaves. Refer to *Summer Cabin* for details in painting techniques.

The snow makes for interesting shapes of the whites in the vignette. Note the lost edge at the front of the house on the left. The lost and found edges of the posts under the porch also create an imprecise indication of the structure. Just enough is shown for the mind to complete the image without challenging reality. Note how the whites are designed to go in and out and around the entire edge of the vignette.

The bright color of the building is emphasized by the cool blue of the sky and trees, along with the pure white paper. The shapes are varied for interest—no two are exactly alike. Some of the trees are positive and some are negative. Contrast, variety, interesting shapes, and lost and found edges are the ingredients needed to create good design.

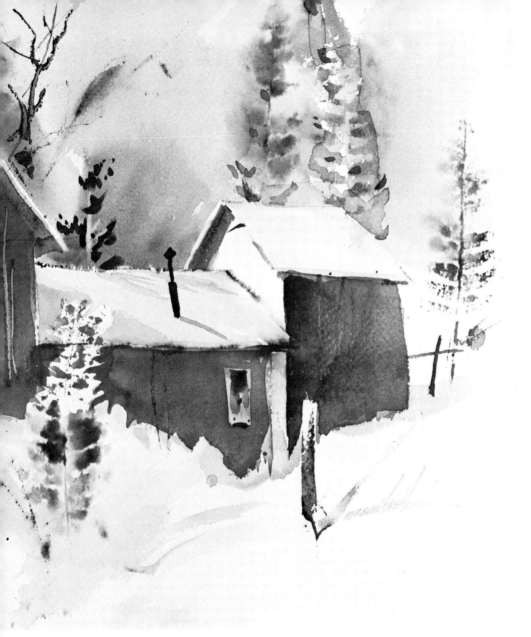

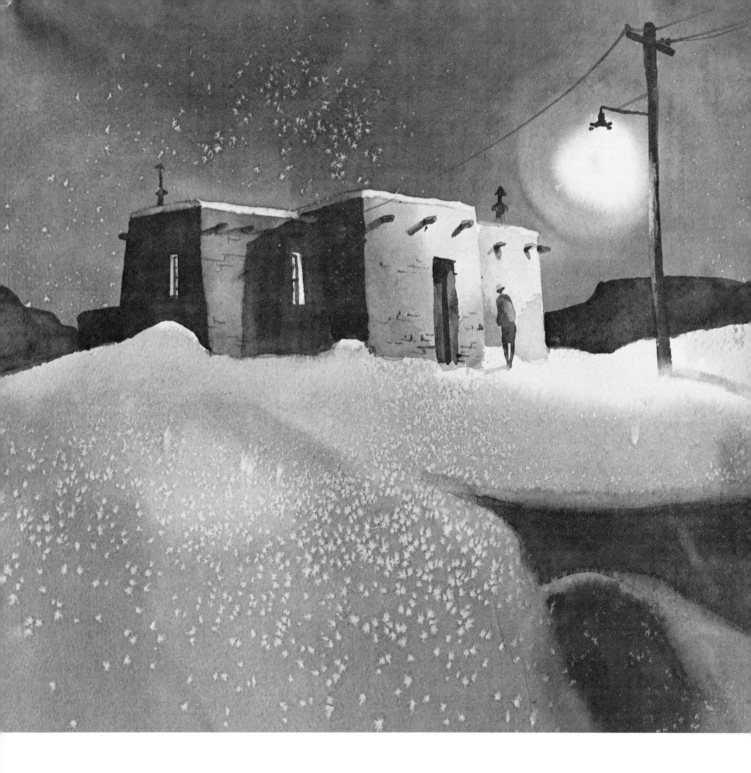

The Light Source

The warm adobe building is lighted by an outside lamp, making a bright area that intensifies the dark sky and the cold night. The adobe is also lighted from within with little slits of warm light showing at windows. It is advisable to keep doors and windows on houses rather small. If they are too large, they dwarf the house and make it seem like a doll house.

This adobe is on a hill, so the horizon line is fairly low. The scene is viewed at some point down the hill looking up at the house so the parallel walls converge slightly toward the top, making a small suggestion of three-point perspective.

110

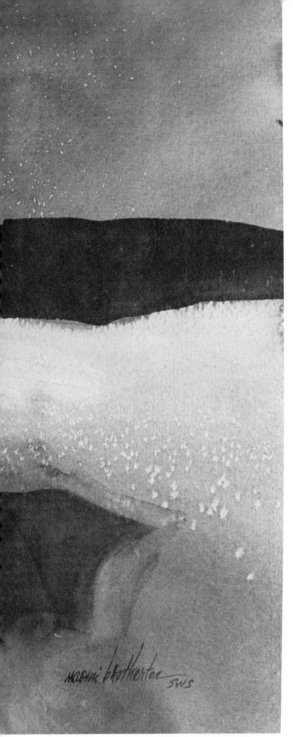

The Quiet Hours

Quill and Ink Drawings

The quill is an ideal drawing instrument because it makes a beautiful variety of lines. It is a pleasure to draw with a quill pen on good quality dry watercolor paper. Twist the quill and turn it, press on it, and lift it. You'll achieve a wonderful variety of thick and thin lines.

A goose quill is best, but a turkey feather quill will do. Cut off the very top, leaving about four or five inches. To make the tip, cut the stem at a 45-degree angle with a sharp knife or razor blade for the point. Flatten and smooth the point with a piece of fine sandpaper. A bobby pin stuck into the hollow shank with the rounded part of the pin down will help hold the ink and will make drawing easier. Once you have a quill, it will last quite a long time, so take good care of it. It can be resharpened as needed.

I have heard of some people drawing with a sharpened match stick. Some people even draw with a cattail. In fact, you might use almost anything having a fine point except a pen, which usually makes a regular, but often monotonous line.

It may help you to lightly sketch first with a pencil for correct placement, perspective and design. A light pencil mistake is a lot easier to erase than the ink. Choose a subject offering a lot of line variations. Then have fun with your quill. The more you vary the line, the more interesting the drawing will be.

Make lines of all sizes. No need to finish every line. Leave room for the eye to move. It helps to keep structural lines precise to impart strength. Don't let your drawing get spotty. Value indications can be done later with washes. Small indications of texture can be effective as shown in the roof in *Terlingua Ghost Town*.

Allow the ink to get absolutely dry before painting. You can force dry it with heat or let it dry several hours. Then wet the paper with a sponge on the back and the front. The waterproof ink will not move. Then drop in soft colors for buildings, grass and sky. Use mostly midvalues. Brush in values and color, not detail.

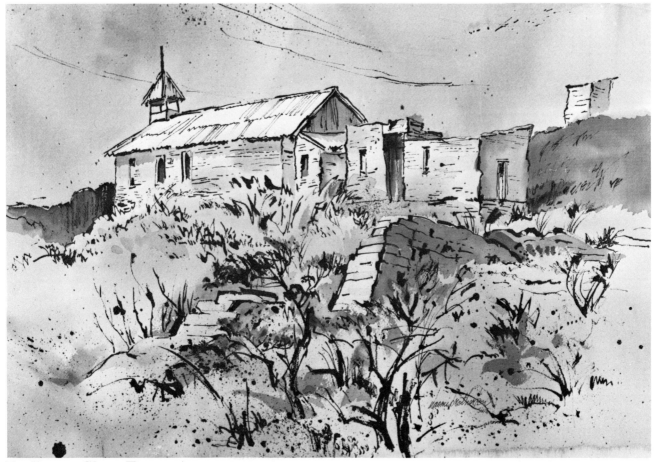

Terlingua Ghost Town

Drawing with a Quill

This drawing was made on location with a quill and Pelikan Black Ink. Note where a double line is used to give strength to the structure, but the lines are not alike. There is gradation in size, with the grasses in front becoming larger and stronger in the ink drawing. They also become warmer in color.

The color has variety and contrast, yet the soft edges have gradation and value change. The color is more realistic in this picture than that in *Mountain Lodge*. The color more closely defines the areas described by the ink. However, the color does not take over. It is definitely an ink presentation.

For a different effect, the drawing can be made with charcoal and sprayed with a fixative and then painted.

The Heart of the City

Buildings as Big Washes

These buildings were painted in the same manner as the mountains in *Big Bend* and in *Vacation Hideaway.* Big washes in correct values were painted directly on dry paper. The far buildings encompass the shape of near buildings, the same procedure used in painting mountains described earlier. The buildings appear darker at the top, silhouetted against the sky, but diminish quickly to a haze. This city scene is not a matter of lost and found edges as in *Cityscape* (pg 106). Here dark is played against light at every interval, vertically and horizontally. The gray acts as a foil to make the subtle warm tones of the church read easily as the center of interest.

There is gradation of color from the cool sky to the warm, dark bushes in the foreground; gradation of value, proceeding from light in the sky to dark in the front, as well as gradation of size. The top shapes of the buildings in silhouette were designed with care to create as much interest as possible.

7 Flowers

Flower Shapes, Wet into Wet

*P*ainting flowers wet into wet best achieves the softness and freshness so typical of flowers. I use Arches cold pressed 140 lb. paper with the top side up, that is, the side on which you can read the watermark. This side is smoother than the other and the "little bumps" are not very deep. They will not cast much of a shadow into the valleys to dull the color. With a thoroughly saturated sponge, wet the paper on the back, wet the support board on which it rests, and wet the top. I usually complete or almost finish flower pictures while the paper is still moist.

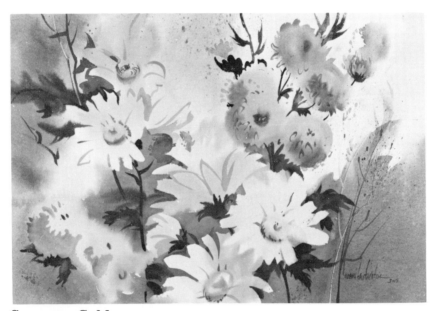

Summer Gold

An Interesting Experience in Beauty

I like to paint flowers without showing the container, as if they were growing in a garden. Freshness of color is vital. Note the overall oblique design pattern; the overlap of flowers, petals and leaves; the breathing space between shapes.

The flowers usually face different directions and have variety in size, shape and value. Do not include too many different kinds of flowers in one painting. Rather, try for variety with the same kind of flowers.

Here the background leaves and calligraphy were painted after the flower shapes were dry.

My aim is not for a realistic painting of flowers. My efforts are not to supply a botanist with information. The painting is only meant for visual enjoyment, showing good design, pleasing colors and a suggestion of beauty.

When the corners begin to turn up, clip them or staple the paper to a board so it will dry flat.

I prefer to have some of the flowers I am painting before me. A bouquet, perfectly arranged, is not required. A few blooms and leaves in a bottle are all that is needed. Leaves and petals and blossoms should be convincing. Different rules apply for good flower arrangements and for good flower paintings. Pictures of any type or subject must be judged on the basis of good design principles.

Choose fresh pigments as near as possible to the actual flower color. Rose madder and Winsor violet are transparent pigments and make beautiful purples for flowers.

If you sketch your flowers with a pencil, do that before the paper is wet. Avoid drawing every petal. Look for basic shapes — cones, disks, trumpets. However, you can wet the paper first and loosely indicate flower shapes with a small round brush, using either raw sienna or a mixed gray to suggest some form shadows as you paint. If you change your mind or do not like a shape, a wet sponge will wipe away the drawing if done before the color dries.

You can control a good petal shape, even on wet paper. Test the paint on the paper for diffusion. If it runs too much, use more pigment and less water in the brush. Remember there is water in the paper. Don't go back into the color and stir it with the brush. You may rob it of its freshness. Put the color down and leave it. Float in the darks with one stroke.

Keep in mind the requirements of good design. Vary sizes — big, middle and small. Create a variety of color by dropping in different hues and letting them flow. Make some edges soft. Some hard. Don't make a lot of stems to lead the observer's eye out of the bottom of the picture. Include leaves and variations of the flower forms. Contrast your lights with nearby darks. Make your darks deep, but transparent. Work for a directional thrust or movement to the composition. Paint flowers looking both ways, look down at some, up at others.

Creating a good design is most important. Break the rectangular picture space into exciting negative and positive shapes, observing a line dominance and contrast. The straighter lines of the stems will contrast with the curvilinear curves in the petals. Remember, contrasts intensify and enliven a picture. The complement is a contrast in color, a straight line will accentuate a curved line, warm color will enhance the cool color. Too much contrast everywhere makes a picture spotty and creates a feeling of unrest. Unify the picture with a dominant color, a dominant direction, mid-tone colors and values.

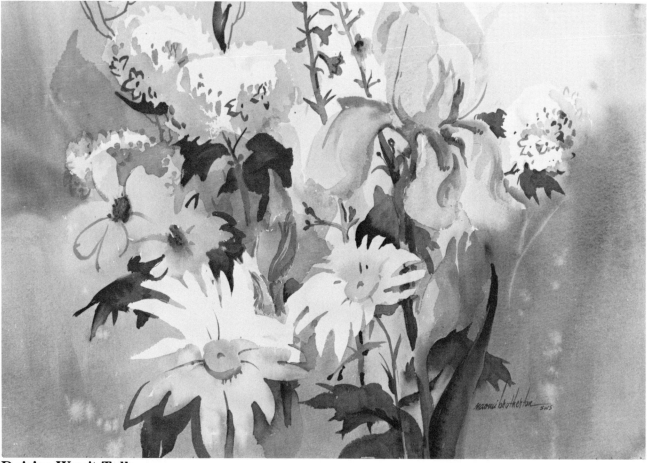

Daisies Won't Tell

Gray Backgrounds

The variations in this cool gray background were done to offset the white and yellow daisies. The purple values reach up to contrast the light area. The light, almost white at the top gives the feeling of atmosphere. The gray shadow sides of some of the white areas have lost edges, allowing them to blend with the background. Notice how some dark leaves form the only shape between some of the petals and the background.

The soft flowers were painted wet into wet. The gray was used to paint around the white flowers and define them. The dark greens and hard-edged flowers were added after the paper was almost dry.

It is an asymmetrical design with a slightly bent vertical thrust. The flowers have breathing space, and the viewer has linking areas in which his eye can travel from shape to shape, color to color.

Shadows in centers and on petals help to give form and a feeling of roundness. Use shadow color to push one leaf or petal behind or in front for depth and to create a value change. Some stems or leaves can be adapted to any color needed in the design.

For the most part, the shadow forms were not painted as the first color was applied to the wet paper. Doing so might destroy the feeling of freshness in the painting. It is best not to work too long in a wet area. If you do you may end up with muddy colors. Also, wet color blends with wet color and you do not achieve the hue you anticipate. Flow in the color, let it dry, and then paint form and cast shadow, using transparent color over transparent color. In this way the colors will not blend, but glow with color and value change.

Variations in the Choice of Backgrounds

Backgrounds can be a warm or a cool gray as desired. Backgrounds can be a dark value or a light value. Neutral gray works well as a complement to the brilliance of the color in a flower painting. Instead of a gray, a warm grayed green may be used for foliage back of the flowers. A dark neutral green also enhances the pure luminous color of petals. On the other hand, you can use a background of the dominant color appearing in the foreground, provided it is grayed with the complement or in some other way. The grayed complement may be used in the background. A yellow flower will be keyed brighter with a background of grayed purple; its complement. Keying a color is to make a hue appear brighter or duller by its surroundings. Yellow flowers next to purple flowers will enhance one another, but a bright purple background will overpower yellow flowers in front of it.

Leaves and stems do not have to be green. They can carry out the color scheme being used, and in any color will read as stems and leaves. Value changes also key a color. A yellow flower is inherently a light value because the yellow hue is light. It will appear richer with a darker value in the background. A middle value background with dark values in the foliage and stems will also key the colors. Value gradation in the background can suggest atmosphere if it is lighter at the top and darker at the bottom.

A mid-tone helps tie together the brilliant color of the flowers to the background. The flowers will seem cut out and pasted on unless there is something to form a transition between the subject and the background. A soft-edged area of light mid-tone may be introduced into the negative spaces, entwining through the small openings between the leaves, stems, and flowers. It should have a good shape. It will create a vignette and should also leave a good light, negative shape. A lacework of leaves, stems, and even flowers in a neutralized, harmonious color in lighter values will create another dimension, as if more flowers existed back of the main ones. Vignette backgrounds are adaptable to dark flowers. A vignette of white flowers can look as if the flowers are holes through which you see the white paper. Avoid breaking up the big masses in a vignette.

Spatter can also form a transitional tone between the light areas and the painted flowers. After the positive flowers are painted, or even during the painting, spatter can be put in with paint on an old toothbrush. To do this, gently pull your finger across the paint-loaded bristles of the toothbrush. More spatter can be added later. This will have a different diffusion from the first because the paper will be dryer. Exercise restraint, and don't spatter too much just because it is fun and it works so well.

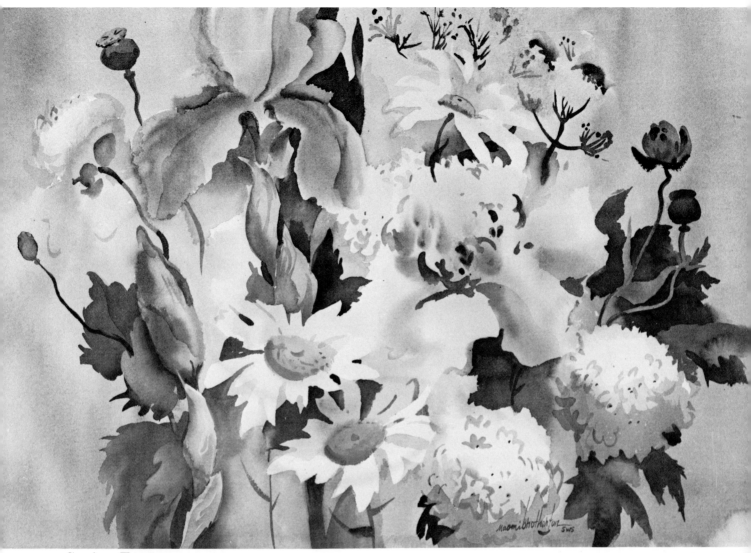

Spring Fantasy

Background - Grayed Hues of the Flowers

The background is a slightly grayed color of the same hue found in the flowers. The grayed green leaves give contrast and shape to the petals. Some stems were lifted from the green leaves on the right. Paper was torn and placed in an interesting shape, side by side, as a stencil. A damp sponge was used to scrub out and lift off the color. Use a thirsty brush to lift color. Wet your one-inch flat brush thoroughly, holding it above the water. Press the hairs between the fingers. Do not pull or it will dislodge hairs and injure the brush. Press out the water until it is like a mop. You wring it out and it picks up water. Your thirsty brush will pick up colored water from the page, leaving a nice light area. This lifting is best accomplished just as the glisten leaves the paper. If you do it too soon it fills again. If you wait too long, the water makes a bloom.

Depth is achieved by using shadows, pushing one daisy behind another and giving form to the mums.

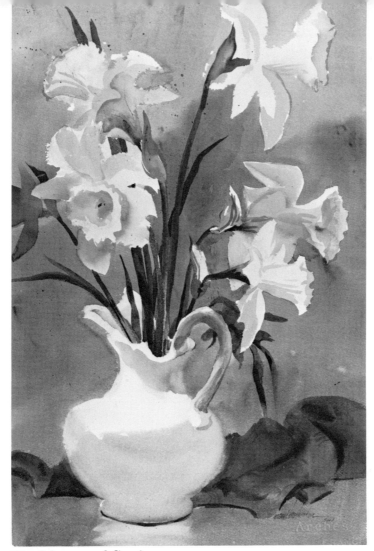

Harbinger of Spring

Background Contrasts

The dark grayed warm background contrasts the clear, brilliant yellow of the flowers and the white of the pitcher. The gray shadow gives form and shape to the flowers. The basic design of the composition is informal as the two sides are not even or alike.

I like to see some flowers go out of a picture area, not necessarily on all four sides, but in one or two places. It expands the area and gives the feeling that there is more than you can see. Colors, lights, darks should not be spotty but pulled together into interesting and related shapes.

Watch your stems and leaves that they do not bisect a picture vertically, horizontally or diagonally. Make additions to pull a symmetrically shaped bouquet into an asymmetrical design.

In making corrections in a painting, more and more I ask myself, "How can I correct it without attacking the problem area directly?"

Often a shape painted adjacent to or weaving across the problem area will save it. This can be done without risking the loss of luminosity by scrubbing.

Cropping can sometimes save the day. This can best be done using an old mat. Cut it at opposite corners and form two L shapes. These can be pushed together to simulate a smaller mat. Use them to study your painting. Sometimes there are nice areas that will make a pleasing picture while other areas in the composition may not be desirable. Mat around the good area until you determine where the design, color and transparency make the best picture. When you cut out this area you have a new and sometimes exciting picture.

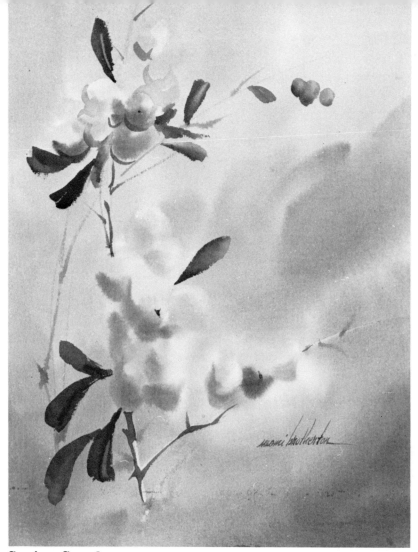

Spring Speaks

Departure from Reality

After painted flowers are dry, you can soften some edges with a wet bristle brush and blot it with a tissue. For variety, some softness can be acquired with a damp bristle brush.

Further variations can be made with stencils. Cut a leaf shape or bud shape out of good paper that will not disintegrate when wet. Use the cut-out positive shape to find the best location and then place the negative mask in the selected position and scrub the open area with a damp natural sponge. You have probably used staining colors so it will not wash out to white, but it will be lighter. It will stay in the background and will be a luminous shape.

A reducing glass is helpful in evaluating your painting. It pushes you back from the painting and you don't have to move. A mirror can accomplish much the same thing. At a reduced scale you can see values and shapes more distinctly.

8 More Variations

*B*atik refers to an Indonesian method of hand-printing textiles by coating with wax the parts not to be dyed. This picture is painted in a method adapted from this old procedure used in dyeing textiles.

Draw a simple design with strong lines on watercolor paper. Use lines that will not fade when wet because you will want to see the design through the watercolor underpainting. Use staining colors so they will not dissolve with water. Make the color strong so some color will be left even after you have washed the painting under a hose. Paint an underpainting with large forceful areas and no detail. Leave soft edges and some carefully placed whites. Work for cool against warm. Be sure to paint a brilliant, strong underpainting.

When the color is completely dry, use white tempera, a poster paint that will wash away in water. The concept of applying this poster paint is important. It is the same process as used in Indonesia in the dyeing of textiles. They apply wax to the part they do not want dyed when they put the fabric into the solution. In this case, we cover with tempera the part we do not want to be covered with black ink. Later we shall use black ink to cover the paper instead of placing it into a dye vat. The tempera will act as a deterent much as the wax does in the dyeing process.

It takes a little concentration to use the tempera correctly. The part you cover with tempera should be the light design that you want to show in the picture. Watercolor painting sometimes consists of painting a glaze around the part you want to leave. Reverse your thinking. Paint with the white tempera completely covering the light you want to show. Later we shall wash off the tempera and the design will appear.

I painted the lantern with tempera and rough brushed the white paint on the background area. Everything that I did not want to be black in the picture, I covered with tempera. I used it just as I would if I were painting a positive design of a lantern. The black in the picture was the only part not covered with the white tempera. An old brush should be used for this because tempera may hurt a good brush.

It is best to wait a day after you have painted the tempera so it will be good and dry before you put on the ink. When the tempera is completely dry, use an old painting brush and completely cover the paper with Pelikan Black Ink. It is of good consistency and is waterproof. Paint the paper, just as if you were painting a house, courageously back and forth, covering the page, painting over the tempera and color.

Allow the ink to dry thoroughly and then put the picture under a heavy flow of water. With an old sponge, while the water runs, wash off all the tempera. The pattern will be revealed with black in the background and in accent. Complete the painting with some calligraphy, glazing, or with whatever you feel is needed.

Lantern

Matte Medium

Using a half sheet of stretched 140 lb. Arches watercolor paper, wet with a sponge, paint an abstract design with soft edges. Decide on a chosen color scheme and a dominant color and use good transparent staining pigments, such as alizarin crimson, ultramarine, New Gamboge, etc. Keep light values because it is an underpainting. However, you want brilliant, clear colors. Use staining pigments so the painting of the matte medium will not lift the color. Let the underpainting dry completely.

Over the dry underpainting apply a mixture of acrylic matte medium, mixed half and half with water. Use an old brush because the matte medium will ruin a good brush. Apply a coat of the acrylic medium over the abstract underpainting. Hold the board up to the light to make sure you have completely covered every spot. Allow the medium to dry completely, at least over night and preferably for several days.

Set up a still life that interests you. There should be good shapes and overlapping objects. You might use flowers, or you can use this method for landscapes.

Review the color scheme you chose, the one you used in the underpainting. You will use the same colors again, only this time you will use different and more varied pigments to mix the colors. There should be a dominant color, some grayed tones and some darks. The possibilities are limited only by your imagination, but stay with your chosen color scheme.

With a light color, probably raw sienna, lightly sketch in your line drawing. Do not try to go with what you see in the underpainting. Deliberately draw your objects so they will overlap background colors and values. Try to keep a directional dominance. The drawing can be abstract, but do not combine both abstracted and realistic drawing.

Check your design before you start to paint. No line should cut the page in half vertically, horizontally, or diagonally. Watch for variety in size of objects and in shape. Create a directional dominance, verticals, horizontals, or obliques, resolving contrast and conflict into a unity. In checking sizes and shapes, keep in mind negative as well as positive shapes.

Glaze your colors with big washes over the underpainting. The matte medium creates a hard surface and wonderful things happen when the liquid watercolor flows and blends and runs on the hard finish. Too much water left standing will cause back runs, some of which can be interesting, but don't develop too many of them.

Collectables

Slowly work your design, painting positive shapes in some areas and negative shapes in other areas, allowing the transparent underpainting to glow. Use a thirsty brush to lift colors. This is easily accomplished off the hard finish, even dark colors and staining colors come off because they will not penetrate the water insoluble surface of the matte finish. Lift areas to restore lights. Simply wet a dry area where you want to lift, leave the water long enough to dissolve the paint and then blot with a tissue or a cloth. You can even scrub it off with a bristle brush. Put in drops of water for textures. Blot with a wadded up tissue or simply paint two colors side by side and allow them to mix. Try some lost and found edges. Allow the light pattern to flow through the painting. The lifts are not strictly a corrective measure. They create special effect of their own.

Fruit and Frame

Sandpaper

To create a variety of surface textures on which you can achieve exciting effects, try sanding the surface of a good quality watercolor paper. In this case I used a rough 300 lb. Arches watercolor paper and fine sandpaper. The sandpaper is wrapped around a little block of wood to control the pressure and make it easier to handle. Do not sand the paper equally all over, but vary the pressure. Leave some areas without sanding at all. Sand some spaces more than others. Sand at random, not giving thought to the design.

Sketch in your shapes and design, visualizing light, dark and mid-tone patterns. Whether the design is a still life or a landscape, it should

include interesting shapes and variety. When you begin to paint, do so with big washes on dry paper. Use a big brush and be bold and decisive, making one clear statement so your color will remain fresh. Paint warm against cool, light against dark, dull against bright, etc.

You can lift with a thirsty brush. Or you can wait until the paint is dry and lift highlights on bottles by using good paper as a mask, and by scrubbing areas with a cosmetic silk sponge. After the first washes are dry, glaze transparent color over dry transparent color to define form and cast shadow. Decide what you want to do and make a clear statement with the well-selected color and value.

Imprinting

It was pure delight to paint these buildings and fences. Why don't you try it? Here is what to do.

Working directly on stretched dry paper, paint a predominantly warm abstract underpainting. You want this color strong enough to read through glazes, but not so strong it will dominate. Keep it from fading out too lightly in the corners and maintain the light and white areas toward the center.

While it dries, decide upon your subject matter, a house or a barn, perhaps. An exaggerated profile will heighten the angles and enhance the design qualities. For more interesting shapes, turn the buildings in different directions. When dry, sketch lightly with a brush or pencil over the dry abstract underpainting.

Before you begin painting, collect your "junk" which will consist of all the imaginative things you can find that will make interesting textures. The textures will be imprinted.

I have found that the following things make interesting textures. No doubt, you will add others.

Collect corrugated cardboard of all kinds — with wide wale, with narrow wale, and with patterns. Many pieces will have interesting edges. You need only small pieces of these boards.

There are all kinds of packing paper with different patterns and designs. Some will be firm and some soft and absorbent.

Styrofoam packaging materials that come in sheets with hexangular patterns, palette knives, old credit cards, and plastic bowl scrapers are useful. Bottoms and lids of styrofoam cups often have interesting designs.

It is fun to develop this type of painting, and you will find more and more interesting texture makers to add to your collection. Your own imagination is the only limit to possibilities.

To imprint the texture, paint a juicy watercolor shape on the cardboards and texture makers, and press the board in the chosen area with the printed side down. Hold it in place until a texture sets, and then lift the cardboard off. Paint a little detergent on the plastic pieces before you paint on the color. Detergent is a wetting agent that will keep the paper from resisting the paint. As mentioned earlier, I like to use the brand called *Joy*. When you apply paint to the cardboard, do not cover the entire board. Paint an interesting shape and the imprint will be more exciting. Decide where you want the texture to show. Keep it either in the sun or in the shadow but not equally in both.

The roof in this painting was imprinted with styrofoam hexangular shapes. The front fence and the back fence were corrugated cardboard, one a negative shape and one a positive shape. Use color change and

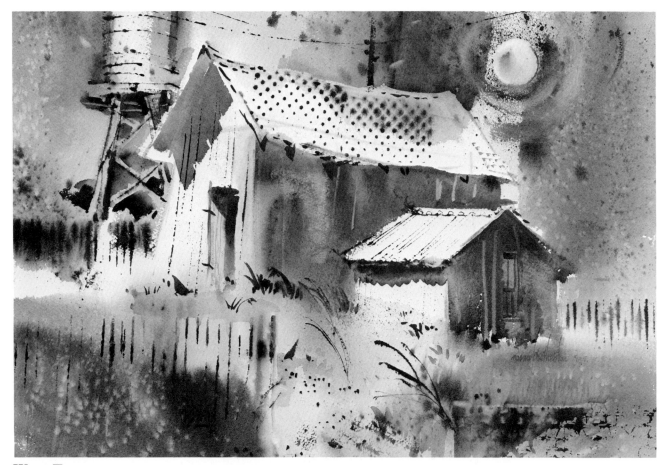

West Texas

value change in the painting on the back of the cardboard and the imprint will be more exciting.

Bit by bit, build up the texture. Make every wash a good shape with variety in color and value. Work for variety. What you do on one side, don't do on the other side. Repeat textures, colors and values as desired. Try to keep the texture from becoming so strong you lose the big abstract shapes that carry the design.

Texture should be used throughout the entire picture. That is not to say that everything should have texture, but it should be a quality of the entire painting. It is not a realistic way of painting. Keep it imaginative, moving; have fun. The sun in this painting appears on the shadow side. Such lighting is employed for the sake of the composition rather than for realism.

Bottles 'n Things

Rough Brush

The secret of this painting comes in the colors and values played against one another and in a freshness created by touching the paper with the brush and wash one time while it is wet. After the wash is dry, you can paint a glaze over it, and it will produce a luminosity like looking through lace.

Use the thick or shoulder part of a one-inch flat brush. Dip the brush flat into the liquid paint and squeeze it out between your fingers. You will get the "feel" of the liquid as you work with this method. With a fairly dry brush, hold it flat underneath the fingers and move it

rapidly so the color chiefly covers the tops of the bumps on the paper. Rough 140 lb. stretched watercolor paper best receives the paint in this manner.

Start with light colors, building the glazes with layers, painting one wash over another only after the first is completely dry. Pay special attention to color over color, taking care not to cover all the first wash. Work for gradation.

The important thing is that the shapes be interesting, varied, and colorful. The entire picture should be painted with a rough brush technique. The aim is to develop a textured look and feel.

9 Gallery

Master watercolorists share some of their
thoughts and feelings about award shows.

Insights into what they look for as jurists.

A personal feeling about one of their own paintings.

An intimate word to all those who love the interaction of water and fluid color.

MEMBERSHIP KEY

N.A., National Academy of Design
A.N.A., Associate, National Academy of Design
A.W.S., American Watercolor Society
F.A.W.S., Fellow American Watercolor Society
S.W.S., Signature Member, Southwestern Watercolor Society
F.R.S.A., Fellow, Royal Society of Arts

King Strut–Judith Betts

Judi Betts, S.W.S.

In the watercolors of Judi Betts, contrasts exist side by side and intermingle with one another in a manner that is both pleasing and captivating to the viewer. Her work has been characterized for the strength of the abstract design from which representational images emerge. Within each work subtle oppositions develop a common unity.

In selecting the subject matter of *King Strut,* the artist assigned the first contrast: while visiting a South Louisiana plantation, she forsook the grand, monumental main house to discover the commonness and simplicity of everyday life.

King Strut himself, a splash of brightness on a painting surface dominated by warm and cool greys, stands out against the background as he does among his peers. He is centerpiece to the reds, greens, and yellows that turn up throughout the painting, and he is at the same time framed by the whiteness of the paper that shines through as the reflection of sunlight on steps and as feathers of his attendant chickens.

The artist contrasts shapes (the large, flat wall and the small, full-bodied chickens), paint (from very transparent to slightly opaque), and color (warm against cool, light against shadow). What emerges is a panorama of oddly magical shapes—the sunlit steps, the grouped chickens, the splashes of color carefully applied in the upper right and lower left corners.

Millard Sheets, the noted artist who was one of the jurors for the 1980 Rocky Mountain National Watermedia Exhibition said that this award winning painting displayed extremely sensitive color perception with brilliant, transparent luminosity.

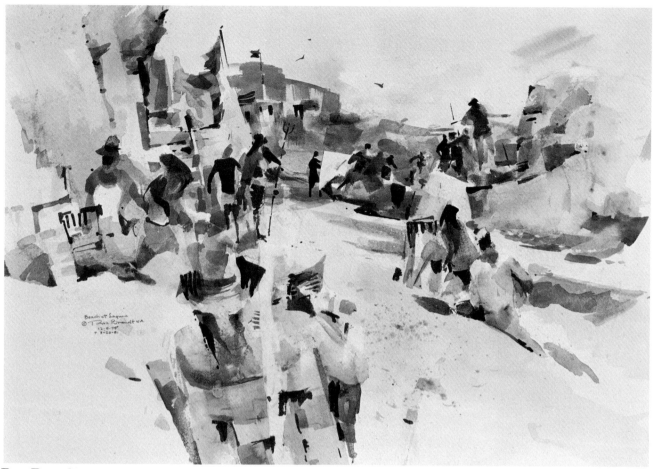

Rex Brandt

Rex Brandt, N.A., F.A.W.S., F.R.S.A.

First you have to "make the show"—get in. Unhappily, what gets in easily seldom wins prizes. The jury of selection is just too snowed with items to do much more than separate paintings which are "on pitch" from those that aren't. The last show I juried had 1600 slide entries. We saw them all twice, plus additional screenings of doubtfuls plus a final look at the selections. Over 4000 slides in one day! Have you ever sat through an evening of even 400?

But the jury of award has it easier, seldom more than 200 pieces, usually the actual art and often already hung. They can search out that uniqueness that separates the winner from the typical but ordinary. The nice but ordinary watercolor that was unanimously accepted is passed over; the daring, not-quite-typical venture which barely got in has a chance to say its lines.

Study the shows and the catalogs and make your own decision. Here are some generalities:

1 Very few direct, on location paintings make it. The studio paintings knock them out, especially if it is a spring show after a long, cold winter. The fall shows are fresher, with some summertime outside works winning.

2 Portraits, or any treatment which focuses too hard on only a part of the sheet won't cut it.

3 Warm-toned palettes win over cool; texture over color; and value patterns win more often than color symphonies.

4 Unobtrusive but effective framing is an absolute must.

5 Too large or too small works have a hard time as do works with large, sloppy signatures, especially if angling across one corner.

6 Works in the style of someone else tend to get judged against that someone else and lose out.

Find and be yourself.

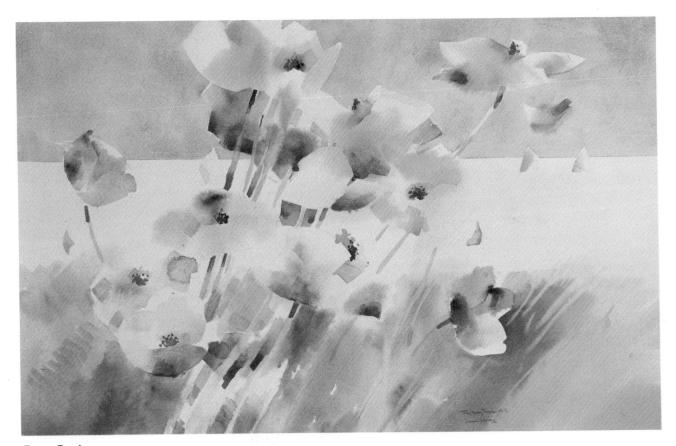

Joan Irving

Joan Irving, A.W.S., F.R.S.A.

From my experiences both as a juror and an exhibitor, I would say that a characteristic of winners is a "musical" quality. Each seems to have a linear rhythm and orchestrated color. No part sticks out. There is a sort of "now you see it and now you don't." Then texture is used as a sort of vibrato to enrich the whole.

In my own things I try to relate these conditions to nature as I am a fairly literal painter. For example, I love the feeling of the wind and the way it sweeps clouds, clothes on a line, cellophane agricultural sheeting, balloons and flowers into a dancing pattern. Or I will explore the repeated patterns of background objects in relation to the figure groups and bouquets I love. Often this pattern is quite architectural, inspired by board fencing, trellises, windows or other rectangular motifs—always rhythmical.

Although I like to travel, I think that one does better with subjects that are near and familiar. Only a few watercolorists can make foreign subjects seem exciting—you have to be a cosmopolite like Mario Cooper or Ogden Pleissner to accomplish this. Regardless, I don't think subject matter is as important as feeling. You just can't fool a jury of award—they are seeking genuine emotion. Even the most abstract winners have to "grab you."

I'm constantly surprised to observe that my fellow jurors don't go for the things in which they themselves excel. I remember especially the way Emil Kosa would turn down other people's rolling hills and sweeping skies—subjects in which he excelled—but would vote for abstractions, something he confessed not to understand.

So, don't try to outguess your jury. Just keep the music coming!

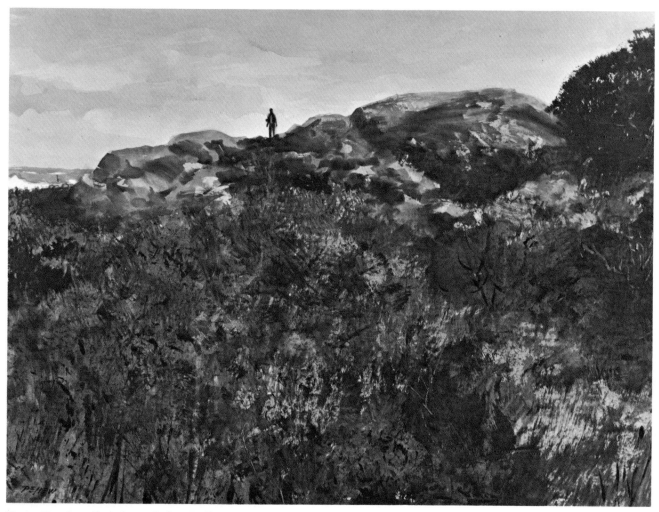

Bass Rocks, October–John Pellew

John C. Pellew, N.A., A.W.S.

What makes a painting a prize winner? Looking at the illustrations in the catalogs of our big annual exhibitions one has to think there's no answer to that question.

However, what *do* the jurors look for today? I answer with these three words: *imagination —originality— impact.*

Perhaps a new way of presenting the old boring subject matter! That's using imagination which will probably bring originality along with it without even trying. Impact depends on strength of design or composition. Of course a painting may be a fine work without having all of the above, but we are dealing here with what causes contemporary jurors to award the prize.

Let's consider my painting, "Bass Rocks, October." The location has been a favorite one with marine painters since the young Winslow Homer painted at nearby Gloucester. The usual approach of all Bass Rock painters seemed to be to get as close to the water as possible and then paint one big wave rolling over and about to strike the foreground rock from which water from the preceding wave is falling in a picturesque trickle. That picture has been done to death. Very well done by specialists in the subject, badly done by others!

I made a quick decision. Why not a marine painting that features the land instead of the ocean? The rocky overgrown foreshore was interesting in color and texture, and there was a glimpse of the surf at the upper left. I added a figure to establish the scale of the scene. I like to think of him as painter number 500 going down to paint that breaking wave.

My painting was done in the studio from a quarter sheet painted on the spot. I like to think it had an impact on the jury because of its bold design and original approach to a marine subject.

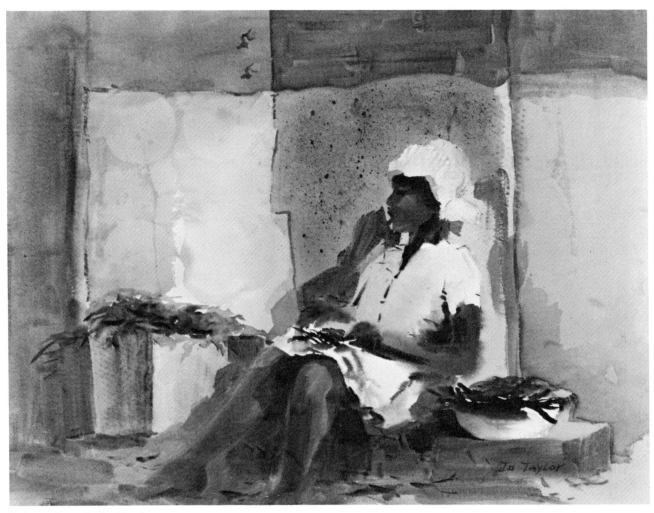

Better Land–Jo Taylor

Jo Taylor, A.W.S., S.W.S.

It was a crisp, beautiful morning when my special sister took a drive with me in search of a "girl day." There in the sunlight sat the beautiful black girl shelling peas. She was silhouetted against the rustic, beaten boards on the porch of her home, asking for no more, perhaps never having known the need for more. Or perchance she could have been the one I saw years ago in a public place when I wondered, "Why may I sit down and she may not?"

My feelings couldn't be saddened on such a beautiful "girl day." But one thought remained, "It is a better land." The year was 1970.

As we drove on, I felt a surge of pride and a reassurance that mankind had taken one step nearer civilized man.

Art has been a pathway for me toward a deeper understanding of all things, a spirit of joy and hope. Art is a servant of the goddess of beauty. We are its ministers. The inception of an idea had occured, but the job remained of conveying the idea and feelings through an entirely different language made up of symbols, colors, form and structure. I came back to my studio and painted "Better Land."

Feelings vary about man's suffering and man's injustices to man, so I had an amusing thought about using this title. For those who had empathy, "Better Land" might mean the flag, apple pie and equal opportunity. For those less sympathetic it might have a more literal meaning, a better crop of peas. I'll bet I'd better think twice, for who can know a jury? I've been one.

The greatest award "Better Land" received was when a viewer asked, "Do you think the artist intended that to be an American flag in her lap?"

I went back a few years later to tell the first lady of Cason, Texas (population 300) that she had been shown in twelve or thirteen art centers or museums across the U.S.A. But she didn't live there anymore.

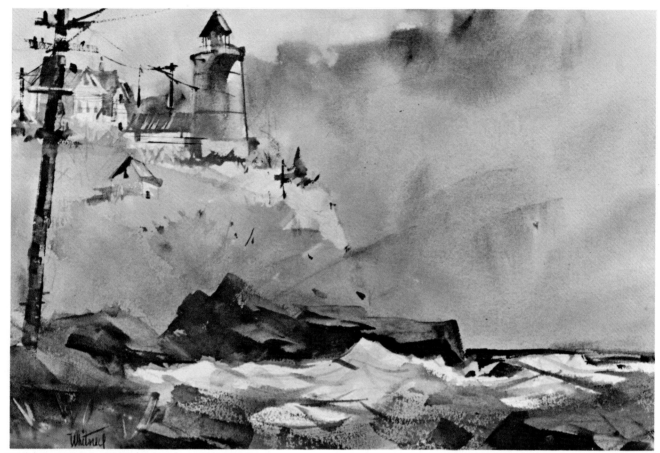

Nubble Light, Maine Coast—Ed Whitney

Edgar A. Whitney, A.W.S., A.N.A.

The virgin rectangle is a problem. Problems are solved by information. Scholars acquire information. Could anything be simpler than that?

All knowledge essential to the painting of a fine watercolor can be obtained from books, many books; from teachers, many teachers; and from subscription to the truth of the pragmatic theory that doing is part of the knowing.

Design principles are ubiquitous absolutes, and their logic is within the comprehension of any teenager. Fine minds agree that art is rational. So does Webster's New International Dictionary, defining *logic* as "the methodology of any branch of knowledge, as in the logic of art."

A fine painting is a fusion of plastic and psychological values, psychological values plastically apprehended. Without that fusion we have illustration or decoration. There is nothing wrong with either, except that being fragmentary, they lack importance as works of art. Art is significant when it is a fusion of both of these components.

There are too many students that do not know that competence can be acquired and taste can be educated. Happiness is increasing one's power. Knowledge is power. Ergo, I can give you a one word recipe for happiness: STUDY. The reward for scholarship is the priceless quality of ease. *His,* only when he knows he knows.

The human spirit and intelligence, despite the odious militia, will continue to create. To the statement, "Force is the ultimate reality," artists will answer as always, "Is it?"

And they will go right on creating and loving, constituting an aristocracy in the best sense of that word, the epitome of the best in human nature. There will always be that kind of person. There will always be increased understanding as a reward for scholarship. There will always be the validity of design. And these things are enough to keep the watercolorist interested, edified and happy in his craft.

138

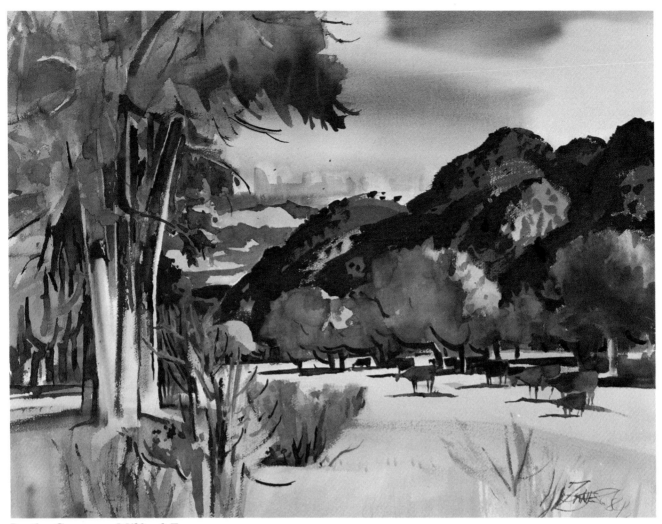

In the Cuyama–Milford Zornes

Milford Zornes, A.N.A., A.W.S.

"In the Cuyama" is a 30 x 40 inch paper. It is a scene overlooking the remote and beautiful Cuyama Valley in a part of California that is still pastoral, untouched and reminiscent of the landscape with which Milford Zornes has lived all his life.

The picture is typical of his style in that it was done directly, and, for all intents and purposes, finished on location. It was invited for showing in the 1976 membership exhibition of The California Painting Society in a special category of works by past presidents of the society. Later it was selected by the acquisition committee of the Corcoran Gallery of Art in Washington, D.C. for addition to the National Collection.

Jane Livingston of the museum staff writes:

In this picture, Milford Zornes, a master in the watercolor medium, evokes the precise tone and atmosphere of the rural California landscape. Through a nearly miraculous synthesis of rich modulated color and vivacious brush handling, Zornes makes us virtually feel the air he breathes as he is painting the Western landscape, but even apart from our own appreciation of the place depicted, we value the work itself in its abstract qualities.

10 Good Design

*I*n climbing a high mountain, it is an enjoyable experience to pause and look back to the place where you began. It is always amazing to discover how far you have climbed. And now it is time in this study to look back to the place from which we began. Our main concern has been watercolor painting technique, incorporated with principles of good design. How much have you learned?

In music, an unvaried tone or pitch can become so tedious and grating on the ear and nerves that a person seeks refuge from the torture and sometimes screams for relief. That is monotony. Monotony in painting consists of shapes, colors, sizes, textures and values that lack sufficient variety. Variety relieves monotony. Variety is essential to good design.

Conflict and variety dramatize life and also art. Conflict in painting is what the plot is to the play or novel. It is interest and excitement. Repetition is monotony, variety is excitement.

An artist works with tools of his trade. The watercolorist uses water, paper, brushes and pigment. With these he can paint lines, shapes, values, textures and colors. An artist cannot put a house in a picture. All he can do is paint shapes that allow the observer to think of a house. If those shapes, colors, values and textures in the picture are interesting, the picture will be a success.

We know variety is achieved in the division of the picture space into two unequal spaces. One major factor in determining space division is the choosing of the angle from which the picture will be seen. Should the horizon be high or should it be low? One thing is certain; you usually want to avoid placing it directly in the center.

Also, every line you use to define a form in your composition has direction. They can be horizontal, vertical or oblique. A horizontal line can contrast an oblique line. If one directional line is repeated with variations, it becomes dominant and can give unity to the design. Lines may be curved or straight, thick, thin or broken. Lines should not be exactly the same, but they can be repeated with some variation, creating a kind of rhythm and movement.

Geometrical shapes — squares, circles or triangles — are only a few of the many shapes that exist. How do you know when you have good picture shape? Basically, you can't identify a good or weak shape when it is isolated from its surroundings. You must decide on its efficacy only as it relates to the other forms and shapes within the picture. *Relationship* — how the various elements work together — is the key to good design.

Contrast may involve many elements at once, such as size, shape, value, hue and texture. But a picture consisting only of contrast and conflict becomes chaos. Through gradation, varied repetition, dominance and balance, a pleasing unity must be established if the picture is to have harmony and visual effectiveness.

Unity is a oneness, a condition of harmony, an undivided, total effect. It is cohesion and consistency. In a picture it is the presentation of a single thought or idea that is easy to read and understand.

Size and shape of the watercolor paper you use represents the picture space and in itself does not dictate, but suggests the type of picture to be painted. A unity exists between the shape of the paper and the subject of the picture. A dominant shape either in size, color, or location will help achieve unity. Repetition of a shape with variety in color or size will also help achieve unity.

Color, value and texture arouse an emotional reaction separate and apart from subject matter. They usually create the viewer's first impression. They should possess variety and contrast. They also should produce unity either through repetition with variety, gradation or dominance.

Dominance means emphasis. One shape may be dominant by size, repetition, color, value or texture, and sometimes by all of these.

Gradation is a pleasing and harmonious arrangement. It can be found in nature in the arch of the sky showing gradation of blues darker overhead, becoming lighter as they go towards the horizon and are dimmed by the atmosphere. Gradation implies change and movement. Unity is essential to good design, but visual interest demands that it be dynamic and changing.

And finally, the mat and frame further isolate the painting, bringing its elements together. It is important to place a mat on a watercolor to study it for good design. In matting and framing a picture, a prime concern is that the mat and frame do not pull the eye out of the painting. In framing and matting, attitudes will change as well as customs, tastes and trends. Interior decorators love to pick up room colors and do not always give sufficient concern to the proper framing of the picture itself.

Chiefly, mats and frames should not detract from the picture, but should enhance it. A white mat sometimes tends to overpower a painting. A neutral color, with a grayed tinted interlining of small dimension often does the most to enhance a painting. Usually, a night scene should not have a mat and frame that are so light they draw attention and compete with the light in the picture. A mat and frame should not be busy and take attention from the picture. The best frames generally are neutral colors in middle values. Too much contrast between the frame and mat is unattractive and draws the eye out of the picture.

In hanging a show, I like to alternate warm and cool pictures. It is also advisable before hanging to stand pictures back to back and front to front to keep screw eyes from injuring the painting next to it.

Over a period of time the chemicals in the cardboard back to pictures and in the tape with which it is attached to the mat discolors the watercolor painting. To correct this problem, back the picture with a piece of 100% rag paper. Attach the painting to the mat with small 1 x 3-inch strips of watercolor paper and wheat paste across the top only, to allow freedom for expansion due to weather conditions.

In the back of this book *Good Design* is the only topic indexed. You will find summarized the elements and principles of good design listed page by page as they were presented and discussed, fitting into place like the pieces of a jigsaw puzzle.

Good design is vital to a painting, but it is not an accident that happens or some mysterious phenomenon over which you have no control. The artist is the *creator* of good design. It begins with your choice of the size and shape of the paper, and proceeds with your every line, shape, color, texture and value. You use variation for excitement, create a center of interest, variety in repetition, dominance and balance, and you achieve unity. Design is creativity in full bloom.

Glossary

Analogous refers to a color scheme that uses adjacent colors, neighbors on the color wheel. Use no more than one-third of the color wheel at a time, four colors only.

Arbitrary use of color is color selected at will, without any relationship to reason or reality.

Backing is the cardboard used behind the painting in its frame to keep it rigid.

Balance is the equilibrium of opposing forces. Formal or symmetrical balance occurs when two sides are alike. Informal or asymmetrical balance achieves equilibrium without the two sides being alike. It is less stately, less obvious, but often more interesting.

Blooms or backruns occur when more water is added in the brush than is in the paper. The excess of water makes a circle which sometimes dries with hard edges.

Color scheme refers to a planned choice of colors, usually one of the recognized harmonious color relationships that uses intervals of color to produce harmony.

Complement is the color diametrically opposite any given color on the standard color wheel. Mixed together, the two colors neutralize one another and make a gray.

Complementary color scheme is one that uses two colors opposite each other on the standard color wheel.

Complement plus one-half is a color scheme that has three colors. It uses the chosen color, its complement, and the color in the middle between the two colors, going either to the left or to the right of the complement on the color wheel.

Calligraphy comes from a word which means *fancy writing*. Brush strokes are used to make a variety of different lines referred to as "brush writing."

Design refers to the arrangement of elements that go into a picture.

Direct painting is painting on dry paper without prewetting it. Hard edges usually dominate unless they are softened with a thirsty brush.

Dominant means an obvious element of design, value or color that is vigorous and eyecatching.

Edit means to alter, adapt, refine, or to bring about conformity to a standard. Editing a picture should take place not only when it is finished, but at many stages throughout the painting process.

Glisten is the shine that water gives to the paper when it is first applied. As the water soaks into the paper, the shine disappears.

Gradation is change, usually a slow change representing several steps. There can be gradation in value, color, and size, in directional lines, and in hue, texture and shape.

Graded wash is an application of continuous liquid pigment, moving gradually from light to dark by adding pigment, or from dark to light by adding water. The latter is easier.

Hue is the identifying name of the color, like red, blue or orange.

Intensity is the degree of brilliance or dullness of a hue or color. A grayed color has a reduced intensity.

Interlocking refers to edges that have protruding and receding shapes at uneven intervals so that the surrounding area flows into it.

Lace is pattern resembling the openwork of ornamental lace as in a network formed by limbs and twigs or by the piles and bracing under piers. It may be dark against light or light against dark.

Light bounce means reflected light. For example, when the sun strikes the earth, a warm light bounces up under the eaves or porch, or into shadows, giving them gradation of warm to cool.

Limited palette is the use of a few chosen pigments with which to paint an entire picture. Often a warm color and a cool color are used together.

Luminosity means brightness, having the quality of light; glowing.

Monochromatic is a color scheme that uses only one color in all its tints and shades, brilliance and dullness.

Mother color refers to any chosen color, a bit of which is mixed into every color used in a painting. A mother color tends to tie together all the hues in a picture.

Nature's green refers to a shade of green commonly found in nature. It is a warm green. There are many greens in nature, but most of them are much warmer than you think.

Negative shapes are the shapes of the unoccupied spaces between tangible objects such as trees, rocks, etc. Negative shapes are often in objects, such as sky, grass, and space.

Oblique refers to a line or shape that is neither horizontal or vertical. It has an axis at a definite angle to sides of the picture.

Opaque refers to pigment that stops the light and does not let it pass through the color to be reflected by the white paper.

Perspective refers to the drawing of objects on a plane with spatial relations as they appear to the eye. The eye sees the sides of a house becoming smaller as they recede, and we feel that there is distance.

Plane change accent is the dark nearest the light as the form turns away from direct light into shadow. It is cooler and darker than the light bounce on the farthest plane from the light. The shadow side of a cube is coolest and darkest where it turns away from the direct light, and gradation occurs toward warmer color and lighter value as the eye moves across the plane. This light sequence also occurs on cylinders, spheres, pyramids and cones.

Positive shapes are the shapes of objects in a picture.

Purist is the name watercolorists like to apply to themselves when they do not use white pigment in any form.

Semi-triad is a color scheme that uses three colors, the color chosen, its complement, and, skipping the color adjacent to the complement, it uses the next color. You can go either to the left or to the right of the complement.

Split complement is a color scheme that leaves out the opposite color on the color wheel, but uses the two colors on each side of the complement together with the chosen color.

Stop refers to devices used to keep the eye from going out of the picture. A center of interest pulls the eye back into the picture. Interesting mid-tone shapes at the sides say, *stop*, before the eye travels out of the painting.

Support is any contrivance used in a design to strengthen or point up the center of interest. Also the board or surface which holds the paper is considered a support.

Thirsty brush refers to pressing the wet hairs of the brush between the fingers until you have squeezed out most of the water. The thirsty brush will when applied to a wet area of a painting, lift colored water from the paper.

Transparent means to see through. The color that is transparent lets the light shine through and the white paper underneath reflects the light and the hue.

Triad is a color scheme that uses every fourth hue on the color wheel. The color scheme of greatest contrast is the one that uses the three primary colors, yellow, red and blue.

Underpainting is a wash applied to the paper and allowed to dry before applying another transparent wash over it. The two washes together produce a third effect. Luminosity is often gained by this step.

Value is the darkness or lightness of a color. In watercolor gradations of value are achieved by the amount of water used to dilute a pigment.

Wet into wet is the application of color to a thoroughly saturated watercolor paper producing soft edges at value and color changes. By prewetting any area of a dry paper, one may also paint into it wet into wet. This procedure produces soft edges.

Index

Bibliography

Brandt, Rex. *The Artist's Sketchbook and Its Uses.* Reinhold Publishing Corporation, New York, 1966.

Brandt, Rex. *The Composition of Landscape Painting.* The Press of the Rex Brandt School, Corona del Mar, California, 1959.

Brandt, Rex. *Watercolor Landscape.* Reinhold Publishing Corporation, New York, 1963.

Brandt, Rex. *The Winning Ways of Watercolor.* Van Nostrand Reinhold Company, New York, 1973.

Brommer, Gerald F. *Transparent Watercolor: Ideas and Techniques,* Davis Publications, Inc., Worcester, Massachusetts, 1973.

Graves, Maitland. *The Art of Color and Design,* McGraw-Hill Book Company, Inc. New York, 1951.

Pierce, Gerry. *Painting the Southwest Landscape in Watercolor,* Reinhold Publishing Corporation, New York, 1961.

Pellew, John C. *Painting in Watercolor,* Watson-Guptill Publications, New York 1973.

Pellew, John C. *John Pellew Paints Watercolors,* Watson-Guptill Publications, New York, 1979.

Pike, John. *Watercolor.* Watson-Guptill Publications, New York, 1973.

Reid, Charles. *Figure Painting in Watercolor.* Watson-Guptill Publications, New York, 1972.

Reid, Charles. *Flower Painting in Watercolor.* Watson-Guptill Publications, New York, 1979.

Reid, Charles. *Portrait Painting in Watercolor.* Watson-Guptill Publications, New York, 1973.

Watson, Ernest W. *Perspective for Sketchers.* Reinhold Publishing Corporation, New York, 1964.

Whitney, Edgar A. *Complete Guide to Watercolor Painting.* Watson-Guptill Publications, 1974.

Wood, Robert E. and Mary Carroll Nelson. *Watercolor Workshop,* Watson-Guptill Publications, 1974.